IMAGES
of America

ARLINGTON

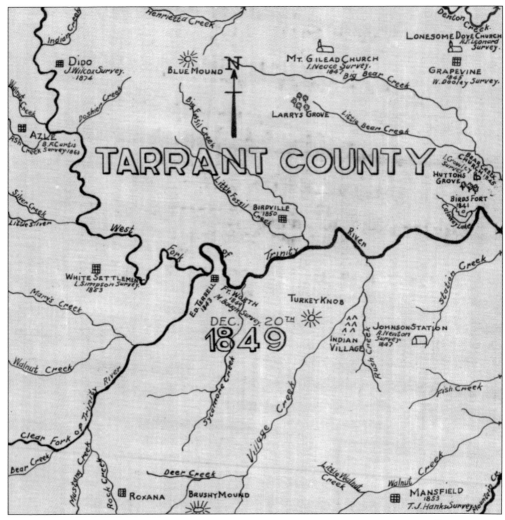

Hand-drawn by Tarrant County judge C. C. Cummings, this ink and linen map illustrates the early communities, rivers, landmarks, and historical sites of the county named for Gen. Edward H. Tarrant on December 20, 1849. Johnson Station, soon to be part of Arlington, Texas, is located in the southwestern corner. (Courtesy Special Collections, The University of Texas at Arlington Library.)

ON THE COVER: Arlington was evolving from horses to horsepower when an unknown photographer took this photograph in 1916. The town was entering a new era, with modern entertainment such as the Tyrone Power film *Where are my Children?* advertised on the Texan Theater marquee. (Courtesy J. W. Dunlop Photograph Collection, Special Collections, The University of Texas at Arlington Library.)

IMAGES
of America

ARLINGTON

Evelyn Barker and Lea Worcester

ARCADIA
PUBLISHING

Published by Arcadia Publishing
Charleston, South Carolina

Printed in the United States of America

Library of Congress Control Number: 2010938468

For all general information, please contact Arcadia Publishing:
Telephone 843-853-2070
Fax 843-853-0044
E-mail sales@arcadiapublishing.com
For customer service and orders:
Toll-Free 1-888-313-2665

Visit us on the Internet at www.arcadiapublishing.com

*We dedicate this book to all of the libraries, archives, museums,
and individuals who have preserved the history of Arlington.*

CONTENTS

Acknowledgments 6

Introduction 7

1. Becoming a Town: Arlington's Early Years 9

2. The Way We Were: Daily Life 35

3. High Stakes: Sin and Salvation 63

4. Pencils and Pulpits: Community Bedrock 79

5. Destination Arlington: Where the Fun Begins 107

ACKNOWLEDGMENTS

We have been inspired by many people while researching *Arlington*, from townsfolk who took the time to share their memories to scholars who researched and wrote about the town. Without their help, this book could never have been written. In particular, a debt is owed to Arista Joyner and O. K. Carter for collecting and compiling Arlington's history for future generations. Special acknowledgment is due to the University of Texas at Arlington Library, particularly the staff of Special Collections and most especially to Cathy Spitzenberger for her invaluable help in locating photographs. Many of the photographs were obtained from the University of Texas at Arlington Library Special Collections, especially the J. W. Dunlop Photograph Collection, the *Fort Worth Star-Telegram* Collection, and the *Arlington Citizen-Journal* Collection. Unless otherwise noted, all images appear courtesy of Special Collections, The University of Texas at Arlington.

We are grateful to the following individuals and groups who shared photographs, memorabilia, expertise, and reminiscences of days and places long gone: Vickie Bryant, Martha May Martin, William Gunn Jr., the City of Arlington, Six Flags Over Texas, River Legacy Foundation, and Arlington Music Hall. We also want to thank Linda Seitz and the Arlington Public Library for locating and making available obscure manuscripts, Ruth Brock of the University of Texas (UT) Arlington Library for her amazing business research skills, and Gerald Saxon, Ann Hodges, and Mary Jo Lyons, all of UT Arlington Library, for their encouragement and support.

Finally, we want to thank our families and friends who never lost faith in our efforts and offered guidance and encouragement. These good people warrant recognition and deserve our sincere thanks.

INTRODUCTION

From its early origins of just a few families in the 1850s, Arlington has grown to a city of over 380,000 people—far too large for this one book to serve as a comprehensive history of Arlington. In fact, books could be written just about the small communities that existed around Arlington before the city embraced them: Johnson's Creek, Fish Creek, Watson, Sublett, Grace Chapel, The Hill, and Roger's Pasture. These communities existed well into the 20th century and helped form the character of Arlington. Their memory is preserved in place names, family names, street names, and historical markers.

This story really takes off with the arrival of the Texas and Pacific Railroad to Arlington in 1876. Many Texas towns sprang up like weeds around a train stop, but not all of them survived, thrived, and grew domesticated, as Arlington did. The train helped establish Arlington as a convenient midpoint between the larger cities of Dallas and Fort Worth and contributed mightily to Arlington's development. Arlington had a thriving cotton market and tourism trade, both aided by the railroad. Even today, the train is an ever-present force in the city, with the tracks dividing the city into north and south.

Like Arlington itself, the University of Texas at Arlington grew from a few hundred students into a notable institution with a worldwide reputation. Along the way, UT Arlington had eight name changes, went from teaching elementary students to doctoral candidates, joined and then left the Texas A&M system, reflected the South's struggle with integration, and provided treasured college memories for thousands of students. Arlington's public schools also deserve mention. The first brick school building was South Side in 1904. North Side was added later. In 1923, Arlington High School opened for white students. Not until 1965 would it admit African Americans.

The city's early tourism destinations include stories of miracle cures, thoroughbreds, and speakeasies. For many years, Arlington was defined by its mineral well, whose crystals were said to cure all ailments. The well was in the center of town and served as a gathering place and rallying point for citizens. It was later capped and paved over. Horse racing gave the town national exposure as Arlington Downs earned a reputation in the 1930s for its outstanding facilities. Notable horses and jockeys ran at the track, which was built up from farmland by W. T. Waggoner. While the pari-mutuel betting that went on at Arlington Downs was briefly legal, the gambling at Top O' Hill down the road most certainly was not. Top O' Hill, with its bootleg liquor, underground escape tunnels, and gaming tables that could be hidden quickly in times of a police raid, preceded the era when Arlington would become known as Fun Central.

Arlington's many churches provided the counterpoint to places like Top O' Hill. Early congregations met in homes or stores before building their first frame churches. Brick sanctuaries followed. While buildings may have burned and churches moved, many of those early congregations are still vibrant in the Arlington community. An exception is the Berachah Home for unwed women. Between its dedication in 1903 and its closing in 1940, the Berachah Home housed and educated women and their children with the goal of helping them lead productive, moral lives.

Arlington newspapers recorded the comings and goings of the townspeople and the changes happening in the city. The *Arlington Journal* started publication in 1897 and merged with the *Arlington Citizen* in 1957. The *Shorthorn*, the newspaper of UT Arlington, has been in print under the same masthead since 1919.

The town did its part for the World War II effort by conducting bond rallies and scrap metal drives and by sending many young men and women off to war. After peace settled in, Arlington boomed, led by efforts of the "boy mayor" Tom Vandergriff. His accomplishments would fill many volumes. Elected at only 25 years of age, Vandergriff served as mayor for 26 years. Early among his many mayoral acts was enticing General Motors to build a plant in Arlington which brought jobs to the area. Next came the construction of Lake Arlington, which continues to serve Arlington's water needs. The Dallas-Fort Worth Turnpike opened in 1957 and made it easier than ever for people to come to Arlington. Improved transportation aided the development of the Great Southwest Industrial District, which would become the largest planned industrial park in the United States.

Without the turnpike, would Six Flags ever have been the success it became? Opening in 1961, Six Flags turned Arlington into a tourist destination again. The park provided jobs for many students and young adults, including future Broadway and television star Betty Buckley. A companion park, Seven Seas, opened in 1972, but it never had the same financial footing as Six Flags. After four seasons (one as Hawaii Kai), the park closed.

Tom Vandergriff was instrumental in bringing the Texas Rangers to Arlington in 1971, although he became a target for angry residents of Washington, D. C., the team's former home. Many wanted the major league ballpark named Vandergriff Stadium to recognize his efforts, but he demurred. After hosting games for many years, the old stadium was replaced by Rangers Ballpark in Arlington in 1994. Sports continue to be a defining characteristic of the city with the 2009 arrival of Cowboys Stadium to Arlington.

For each thing that has been included in this book, there are dozens more that are not. The authors regret that they could not include more of Arlington's historic businesses, restaurants, and parks. Also omitted are many of Arlington's churches, clubs, and civic organizations that do so much good work in the city. These omissions do not reflect the importance of items included here versus those that are not; rather, they merely provide an opportunity for many more books to be written about this changing, striving, and extraordinary community.

One

BECOMING A TOWN
ARLINGTON'S EARLY YEARS

Texas author Larry McMurtry has no love for Arlington, calling it a "city of cul-de-sacs." He implies that Arlington has no depth and no history, but McMurtry is wrong. Arlington has so much depth and history that it even has its own dinosaur dig, the Arlington Archosaur Site. From the Cretaceous period to the Caddo Indians, Arlington attracted life for millions of years before Anglo settlers came in 1846.

Texas Ranger Middleton Tate Johnson became the first white settler when he arrived to keep the recently signed peace treaty between the Republic of Texas and the Caddo Indians. He moved his family to the area and built Johnson Station, a trading post, general store, and stagecoach stop. P. A. Watson and George Jopling were soon attracted to the small community, and in the 1850s, they built their cabins nearby.

Johnson Station flourished until the 1870s, when the Texas and Pacific Railroad built their line from Dallas to Fort Worth, three miles north of Johnson Station, and platted a new town along the railroad tracks. The merchants and settlers in Johnson Station quickly moved to the emergent settlement which someone—perhaps Rev. Andrew Hayter or James Ditto—named Arlington, after Robert E. Lee's home in Virginia.

Like many railroad towns, Arlington in the late 1800s was a tough Western town with gunfights, saloons, and rowdy transients, but by the first decade of the 1900s, the city had matured into a cotton and grain market town with a population of 1,800. Citizens boasted of electricity, water, and natural gas service and used the interurban line that opened in 1902 to travel to nearby Dallas and Fort Worth.

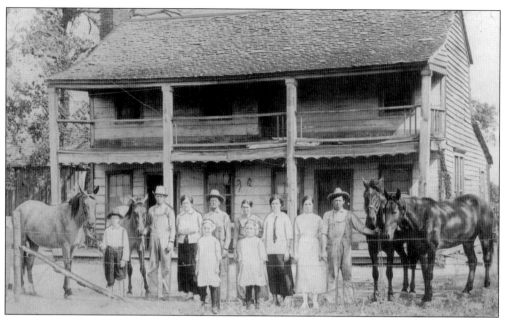

Members of the McFaddin family pose in front of Johnson Station, which was a well-known stopping point for travelers in the 1800s. The station was founded by Middleton Tate Johnson in 1846, when he arrived in the Cross Timbers region with a company of Texas Rangers to form a frontier outpost. Initially a stagecoach and mail stop, many regard the small community as the beginning of Arlington, Texas.

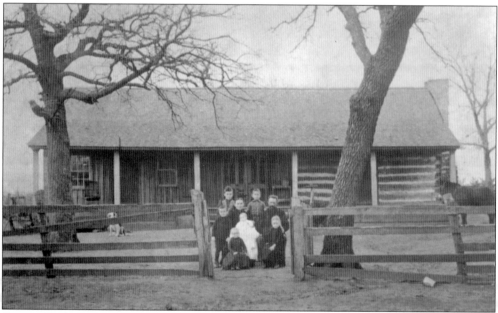

George Washington Jopling moved to Johnson Station and built his log cabin in 1858. In the photograph, the original portion of the cabin is visible on the right side of the structure. Later, Jopling gave the enlarged cabin to his daughter, Jane, and son-in-law, Z. T. Melear. The cabin was moved to the Johnson Plantation Cemetery on Arkansas Lane in 1970 and later relocated to Knapp Heritage Park.

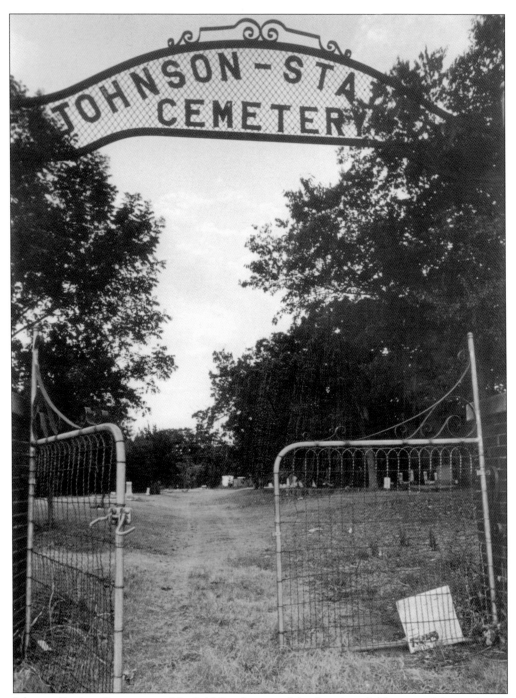

Johnson Station Cemetery on Mayfield Road is one of the few identifiable parts of the vital early community formed by Middleton Tate Johnson in 1856. A Daughters of the American Revolution (DAR) monument just east of the cemetery marks the location of the first stagecoach inn between Fort Worth and Dallas. The oldest marked grave is a memorial to Elizabeth Robinson, who died November 15, 1863. The cemetery is the burial site of early pioneer families Jopling, Melear, and Matlock, along with Civil War veterans and charter members of an early Masonic lodge.

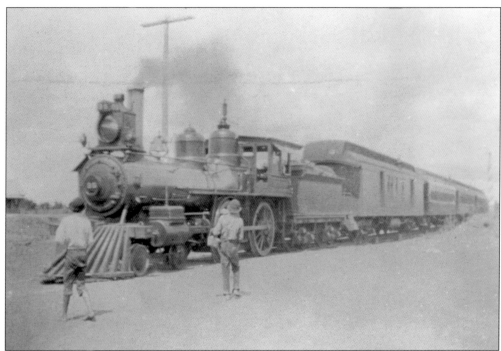

In 1876, Texas and Pacific Railway chose a Dallas and Fort Worth route that bypassed Johnson Station. On July 19, 1876, the first of many trains came through Arlington. Many of Johnson Station's businesses moved north to the new town named after Gen. Robert E. Lee's Virginia home, Arlington House. In this 1896 photograph, the steam locomotive attracts young boys as it passes through the town.

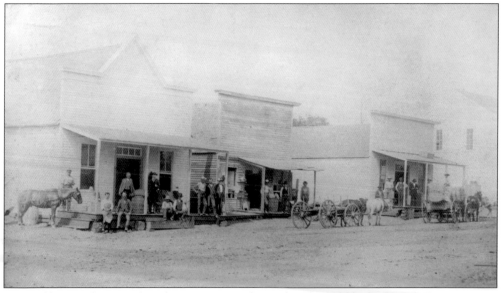

Pictured here, Arlington's first three stores were located in the 100 block of South Center Street. James Ditto's store and post office (right) was moved from Johnson Station to the new railway stop in 1876. The blacksmith shop owned by George Lampe is in the center. Stores and homes rapidly joined them as the train station grew into a community.

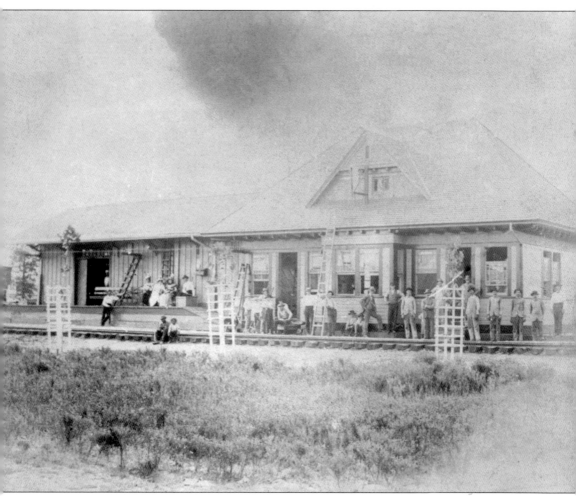

"Three Killed Outright As the Result of a Double Triangular Combat," screamed a *Dallas Morning News* headline about Arlington's most notorious shoot-out. On December 23, 1892, Harvey Spears and "Poker Bill" Smith were waiting at Arlington's train depot for George Byron Hargroves and his sons Walker and George. Spears and the elder Hargrove had agreed to meet to settle a months-long intractable dispute over a horse deal gone bad. Suddenly, within the space of three minutes, 25 shots were fired on the crowded train platform between the groups of men. Women screamed and fainted. Men dove under their train seats. When the smoke cleared, Smith, Spears, and the younger George Hargrove were dead, and the elder Hargrove had been shot. He died of his wounds two weeks later. Walker Hargrove, the sole survivor of the gunfight, was arrested for the murder of Spears and Smith. He was convicted and given 25 years in the Spears murder. The *Dallas Morning News* probably echoed the feelings of everyone who witnessed the "Arlington Tragedy" when they said, "The wonder is that more people were not killed."

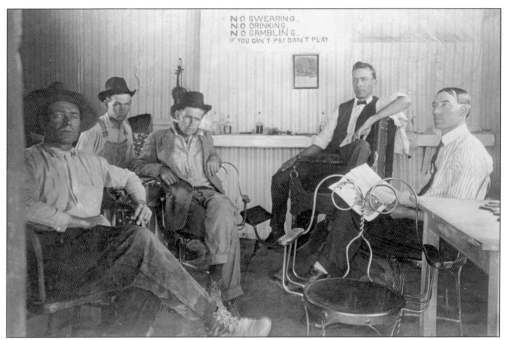

B. E. Wagin (possibly fourth from left) and customers lounge in the first barbershop in town under a sign that reads: "No Swearing, No Drinking, No Gambling. If you can't pay, don't play." In 1898, the town had a rough-and-tumble reputation that led to signs such as this and city ordinances prohibiting the riding of horses into houses.

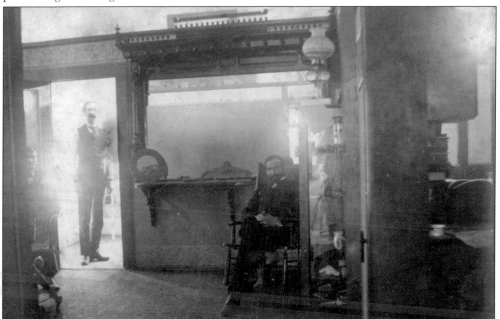

In 1884, Dr. William Harold Davis opened a medical practice in Arlington. Dr. Davis (standing) supported the town by serving as mayor from April 8, 1909, to April 10, 1910, and as president of the Commercial Club. Dr. Davis and Dr. Henry Thompson (right) pose in the dark interior of the town's first drugstore in 1894. The man seated at left is unidentified.

R. A. Randol built this gristmill in 1880 along the south bank of the Trinity River. Randol erected the mill on the site of a previous gristmill constructed by Archibald Leonard that burned in 1862. Randol's mill was soon the center of a small community with a cotton gin, blacksmith shop, and post office.

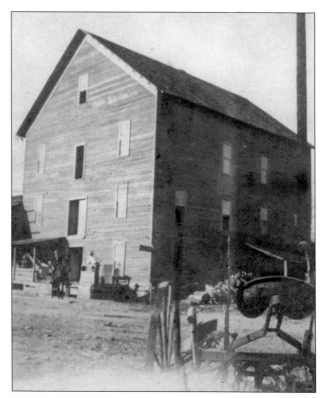

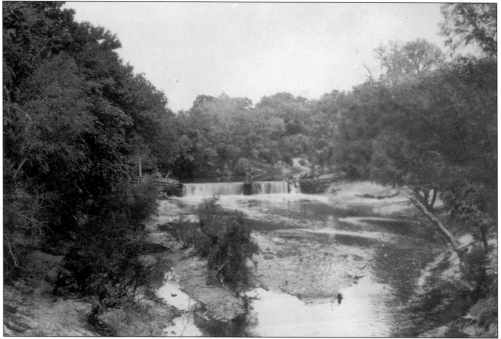

Randol found it necessary to dam the Trinity River in order to get sufficient water pressure to power his mill. The mill and dam remained in operation until the 1920s. In addition to gristmills for wheat and corn, Arlington had five cotton gins operating at one time.

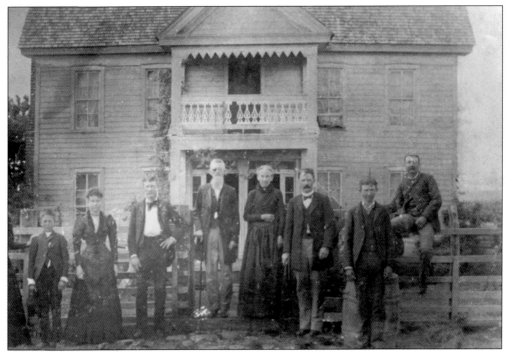

The Matlock family gathered in front of their ranch home in 1891 for this photograph. Located south of Johnson Station, the area remained rural and undeveloped for many decades. Patriarch T. B. Matlock (fourth from left) is the only one identified. The city named Matlock Road in south Arlington after him.

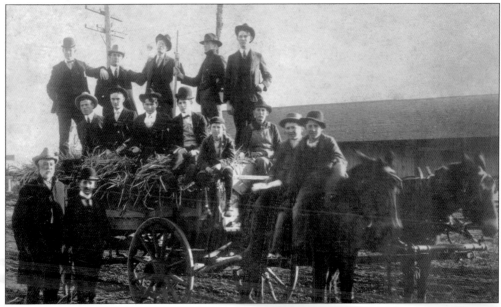

No one remembers why these young businessmen climbed on a wagon at the depot and posed for a photograph in 1902. Their dapper suits contrast with the overalls and work clothes of the driver and youths on the mule. Citizens frequently assembled at the depot to get news of current cotton prices and welcome returning friends.

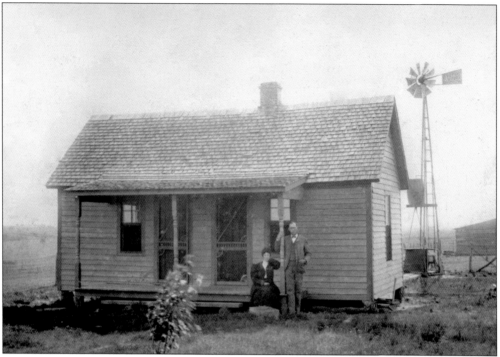

George Willis and his wife pose in front of their simple home in the Webb community in 1905. Similar homes from that era, although modified by the addition of small rooms in the back, remain in Arlington. The city of Arlington annexed Webb in the 1980s.

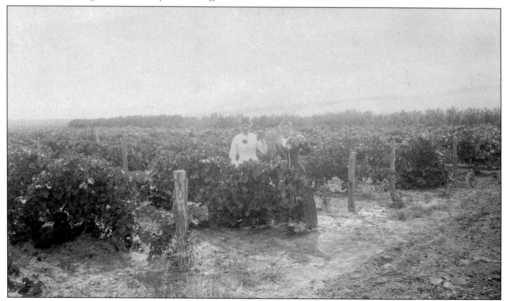

In 1912, Grace Gelhausen and Agnes ? proudly held up ripe grapes in the Hugo Gelhausen vineyard. Texas is one of the oldest wine-producing states in the United States. The sunny and dry climate of Arlington and other Texas regions have drawn comparison to Portuguese wines. Arlington no longer produces wine, but the area has gained a reputation as an established wine-producing region.

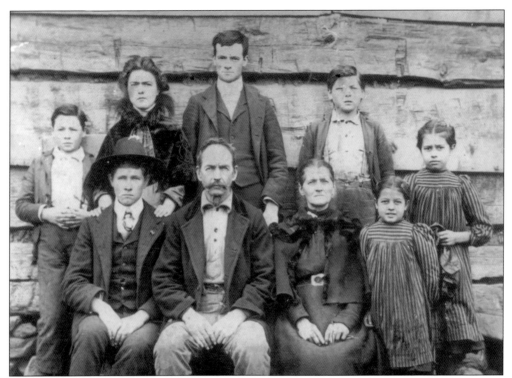

A square-cut log home sheltered the Frazier family during the 1880s. The family dressed in their best for a family portrait that captured the fur-trimmed capes of the women and the matching frocks of the young girls. The Frazier family is typical of the determined pioneers who settled Texas and built Arlington.

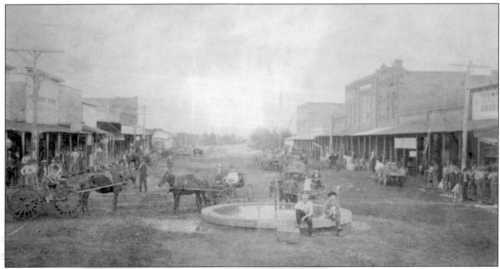

Arlington's mineral well was drilled at the intersection of Center and Main Streets in 1892. This early 1900 version was replaced by an ornate pillar with water flowing through lion heads in 1910. Residents later considered the water to be medicinal, and in the 1920s, Arlington Crystals built a plate glass and brick display room in the intersection. The landmark was the heart of Arlington, where friends met and exchanged news.

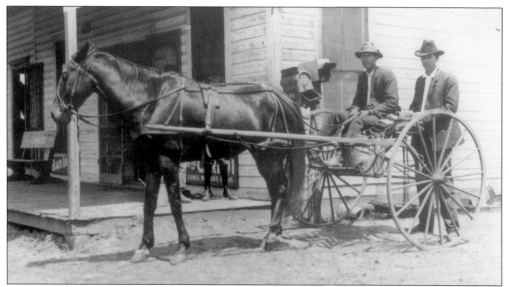

Rural Arlington residents relied on Will Leatherman, shown sitting in the mail buggy in this undated photograph, to deliver their mail and perhaps exchange gossip. (The man behind Leatherman is unidentified.) Leatherman went about his route during the hot summers and icy winters of north Texas. The first-class letters he delivered between 1900 and World War I cost 2¢.

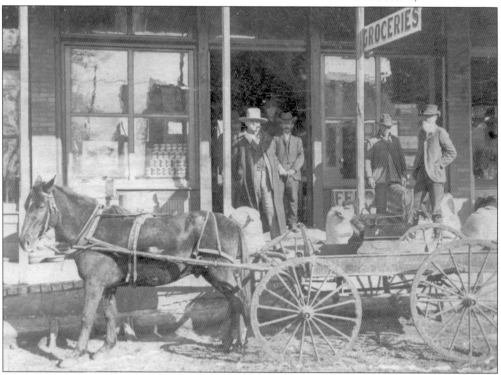

In 1900, the cans stacked invitingly in the window of Rankin's Grocery promised an appealing way for shoppers to spend a Saturday afternoon. The grocery store was among many shops aligned along the wooden sidewalks on Main Street that served customers from both the town and the surrounding farms.

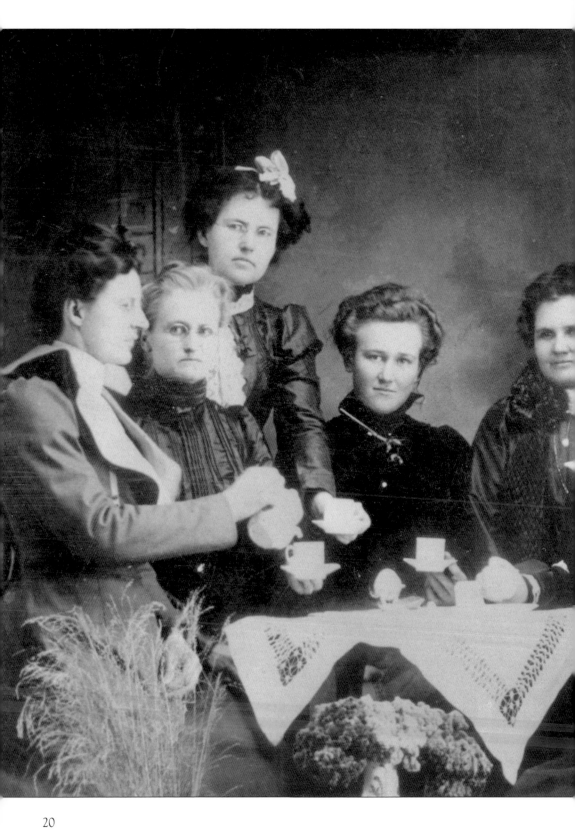

By 1900, Arlington women were meeting for tea and light refreshment at elegantly appointed tables with starched tablecloths and fine china. Having refreshments, from left to right, are Mrs. George Goodwin, Mrs. Benton Collins, Mrs. Nute Noah, Mrs. May O'Neal, Mrs. Bud Douglas, Mrs. Noah Deal, Mrs. A. C. Sublett, and Mrs. W. C. Wade. According to the tradition of the time, they are formally identified by their husbands' names. Despite their demure looks, many women during that decade were active advocates for Prohibition and women's suffrage. Crusading women won broader and greater rights for working-class women and their children through labor organizations, volunteer groups, church organizations, and pressure groups.

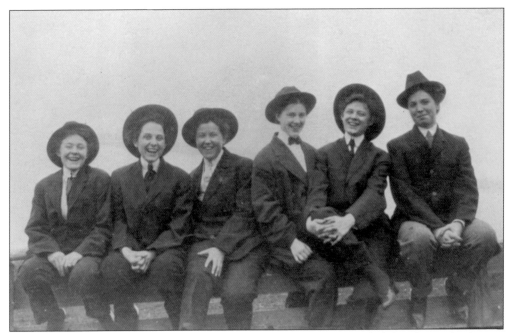

Proper entertainment for young women during the 1900s usually included church socials, dances, and parties, but they sometimes enjoyed harmless fun, such as in this 1911 photograph of young women wearing their father's suits and hats. Smiling, from left to right, are Viva Boothe, Ella Mae Christopher, Jenna Barton, Jessie Christopher, Carrie Christopher, and Gerta Rogers.

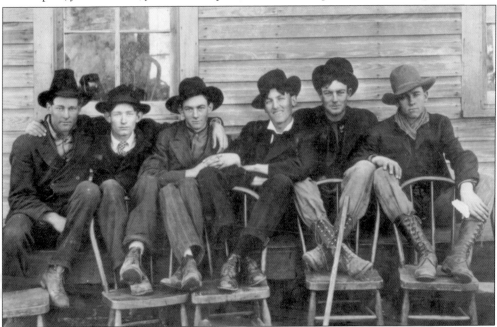

By the 1900s, the founding families had prospered for several generations. Linked arm-in-arm with their feet over the backs of chairs, descendents of the founding families pose in a moment of lighthearted fun. From left to right are Mack Beard, Harvey Swaim, Frank Melear, Vaughan McMurray, Tyler Short, and Julian Melear.

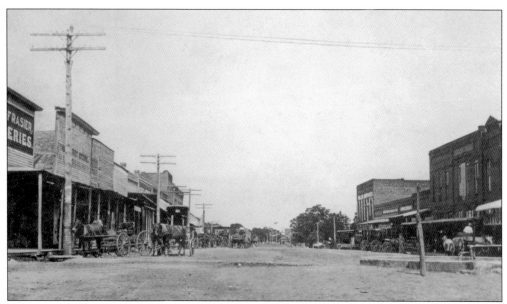

Downtown Arlington in 1908 was beginning to look like a modest-sized town with utility poles marching along East Main Street next to grocery stores and livery stables. Horse-drawn buggies attest to the bustle of market days and cotton sales. The railway tracks and depot are only a block away.

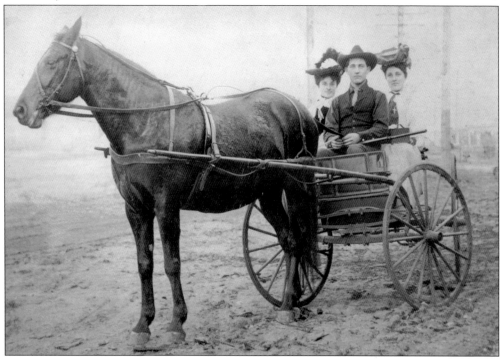

Amusement for the young was often buggy rides, square dances, play parties, or socials. It was important for a young man to have a fancy buggy for courting. In this 1907 photograph, from left to right are Sue McKnight, her brother, Ray McKnight, and Ollie Goodner wearing their Sunday best.

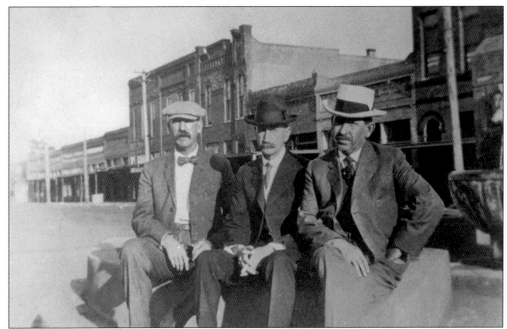

From left to right are Drs. William H. Davis, F. L. Harvey, and J. F. McKissick on the edge of the mineral well. They had more than 100 years of medical practice between them when this photograph was taken in 1915. Drs. Davis and Harvey were among the first doctors in town to purchase cars to use in their practice.

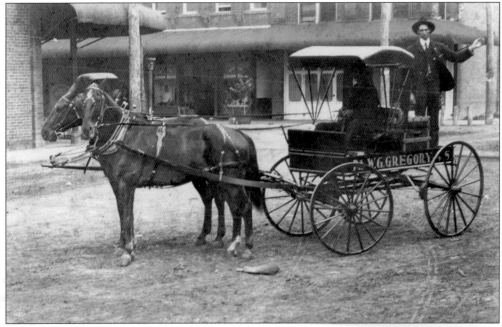

Dr. William G. Gregory and his brother, James, were veterinarians serving Arlington and the surrounding rural areas. The Gregory brothers began practicing in 1889 and were respected horse and livestock doctors who made and sold medicine. Dr. William Gregory (seated) is seen in this 1906 photograph with an unidentified man standing on the back of the buggy.

Several generations of the Collins family, all unidentified, stand on the porch of their home in 1907. Rice Woods Collins built the house in 1885 on the creek at East First and Elm Streets. Collins, a local merchant, started a public subscription to fund drilling for water in 1892 and was dismayed when the well struck mineral water.

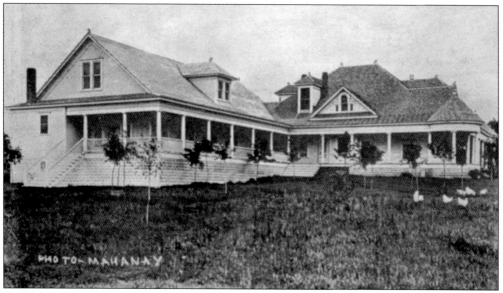

In 1904, Dr. Joseph Donald Collins established a sanitarium that used mineral water for treatment. Doctors and the public thought the water was the same as the famous Carlsbad water and used it for stomach trouble and to cure rheumatism. At the same time, Arlington Crystals made crystals from the water and shipped them throughout the United States. The company sold bottled water at the well and in stores.

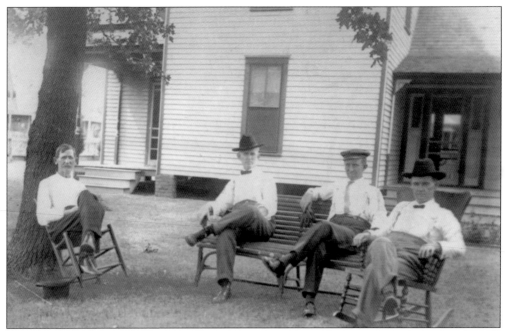

Andrew J. Mahanay and his brother, Fernando W., were the earliest professional photographers in Arlington. Their cameras captured many of the significant events and buildings in the growing town. Left to right, in the shade at Andrew's home at 401 East Abram Street in 1905, are F. Day, C. McKnight, Posey Putman, and Andrew Mahanay.

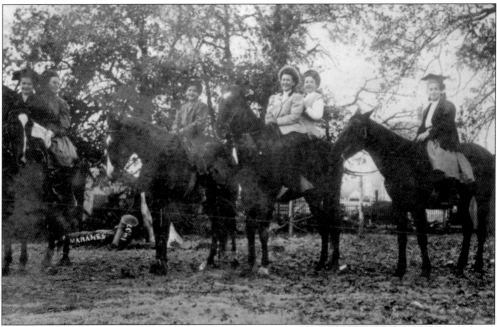

Mahanay captured the fresh faces and enthusiasm of six young ladies as they posed on their horses in 1907. Pictured from left to right are Ethel Roy, Emmie Taylor, Ella Day, and three unidentified women. Like most women during that era, they wished to enjoy their ride while remaining modest, so they used sidesaddles, which allowed them to sit aside rather than astride their horses.

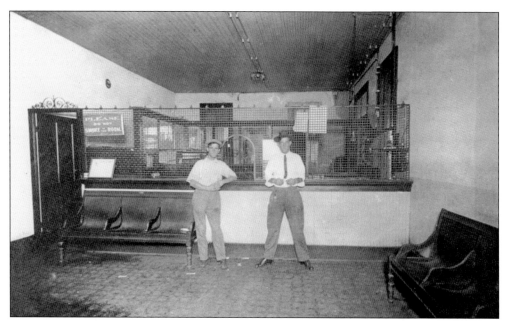

The interurban depot was at the heart of Arlington on Abram and Center Streets and near the Texas and Pacific Railway depot. In 1910, these two unidentified clerks would have sold tickets to commuters, sightseers, and traveling salesmen. During the first decade of the 20th century, town council members began speaking of the advantages of living between two large towns with excellent transportation to both.

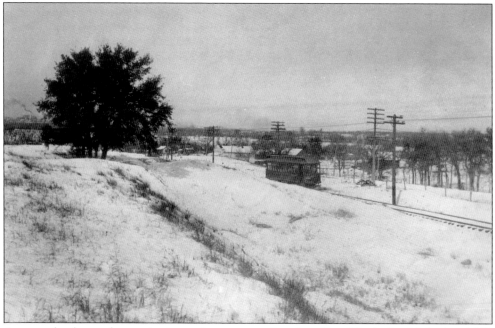

A snowy landscape frames the interurban car traveling from Fort Worth. Established in 1902, electric interurban cars left Fort Worth and Dallas every hour between 6:00 a.m. and 11:00 p.m. and passed through Arlington. Arlington's central location attracted newcomers who could expect to arrive at either city within 45 minutes.

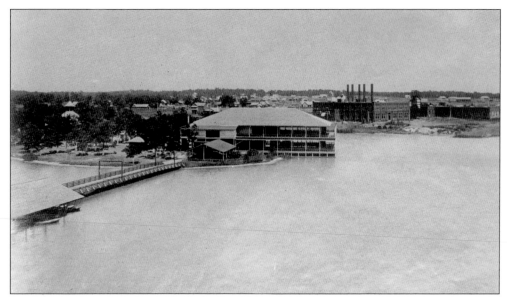

For 5¢, Arlington residents could ride the Fort Worth-Dallas interurban to Lake Erie in the nearby town of Handley. The lake was a water source for the electrical plant that generated power for the interurban. The area developed as a popular park for social events and local outings. In 1912, popular bands played in the pavilion seen in the distance.

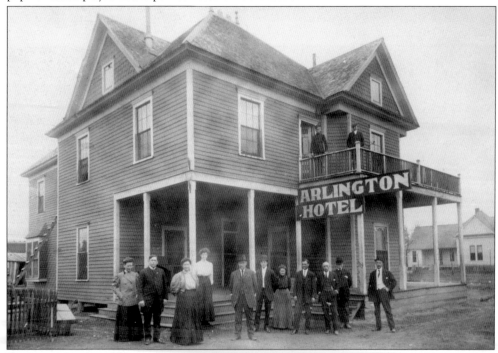

An "up-to-date hotel" opened March 2, 1905, on the 200 block of East Main Street. According to proprietor Joe Ivy, the Arlington hotel would offer the best service ever had in the growing town. Arlington's easy access to the interurban and railway and central location between Dallas and Fort Worth attracted traveling salesmen. They paid $2.50 a day for room and meals. Fire destroyed the hotel in 1922.

James Park Fielder was born in Tennessee and moved to Texas in 1884. In 1887, he married Mattie Barnes in Alvarado, Texas. Fielder was a successful lawyer, banker, and farmer. He served as mayor of Arlington from February 11, 1909, to April 8, 1909, and was an original board member of North Texas Agricultural College, which later became the University of Texas at Arlington.

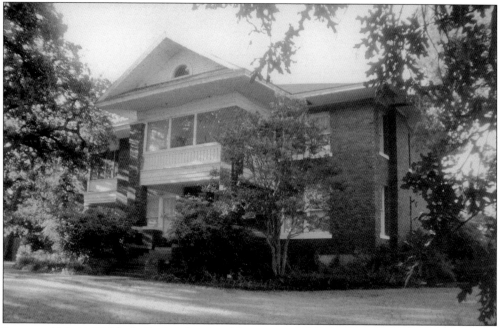

James and Mattie Fielder built their landmark home on a hill located on West Abram Street near the interurban line in 1914. In those years, it was fashionable to build homes near the interurban line so that family members could easily travel to nearby Fort Worth and Dallas. The Fielder home, now the Fielder Museum, originally included 115 acres of farmland. (Courtesy Lea Worcester.)

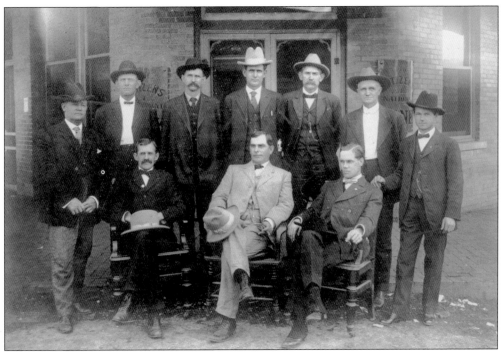

Newly elected city officials gathered in front of City National Bank in 1904 for a group portrait (above). From left to right are (first row) Mayor T. G. Bailey, W. C. Weeks, and Carver King; (second row) J. M. Moore, Dave Martin, unidentified, ? Bushnell, Fine Wallace, Jess McKinley, and Posey Putman. Mayor Bailey served from 1904 to 1906; Carver King served as mayor in 1876–1877 and in 1899–1900; W. C. Weeks served two terms, 1900–1902 and 1906–1909. Arlington Commercial Club members pose in front of an interurban car in 1909 (below). The club was organized in 1901 with a mission to push the advantages of the growing town. The club rebuilt the city's mineral well at Main and Center Streets in 1910.

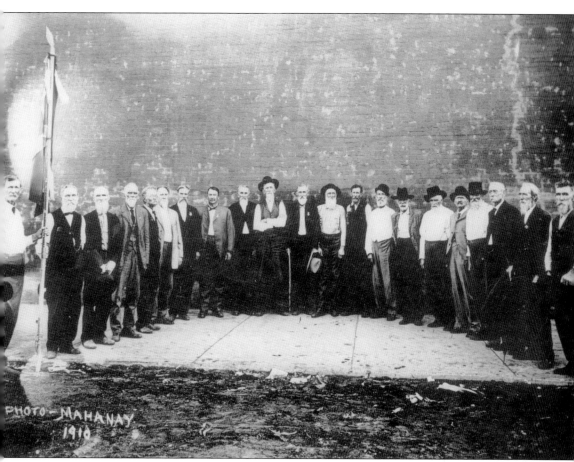

At the start of the Civil War, Middleton Tate Johnson opposed secession, but when Texas seceded, he fully supported the Confederacy. Johnson raised a brigade of approximately 5,000 men but did not serve with his men when he was denied a commission as the brigade's brigadier general. Johnson Station and surrounding communities helped the Confederate cause by smuggling cotton through the blockades established by the Union. Johnson collaborated with the Rhyne brothers, merchants in north Texas, to ship 3,000 bales of cotton to Brownsville using 300 wagons and 1,800 yoke of oxen. Johnson and the Rhyne brothers continued their shipments until Brownsville was captured by the Union army in 1863. Solemn faces reflect the importance of the gathering of former Confederate soldiers in 1910. Whether they enlisted in the Confederate States Army in Texas or moved to the area after the war, the men shared memories and a strong bond.

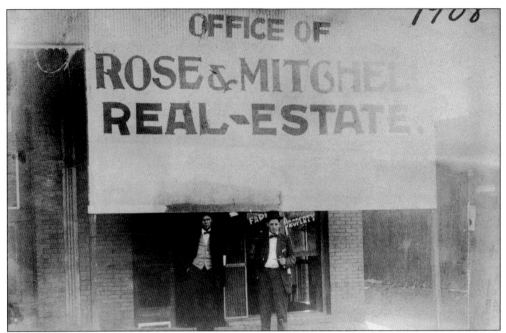

Will Rose and ? Mitchell proudly stand under their enormous real estate office sign in 1908. Rose also owned the Rose Café on East Main Street and, while mayor, oversaw the first city charter, written and adopted in 1920. Rose was mayor of Arlington from October 1919 through May 1923. Mitchell gave his name to Mitchell Street in central Arlington. (Courtesy Martha Rose May Martin.)

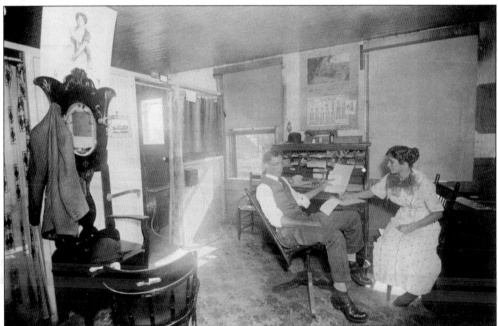

Will Rose (left) hired Arlington's first woman secretary, Floy Brooks (right), in 1911 to work in his real estate office. Women were at that time beginning to leave the home and enter the workforce as office workers. Rose served as mayor of Arlington from October 1919 to May 16, 1923.

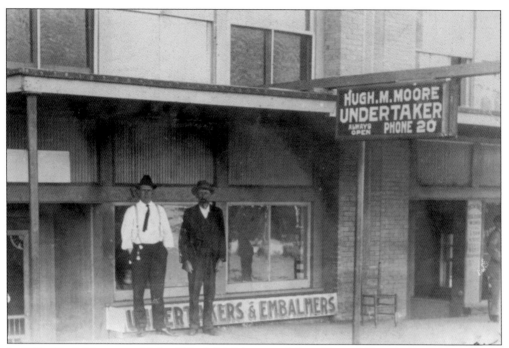

In 1910, Hugh Moore established Hugh M. Moore and Sons Funeral Home in a furniture store. Furniture and caskets were sold in the front, while funeral services were held in the back. This early photograph depicts Moore (left) standing in front of the store with ? Spear. Moore served as mayor from April 7, 1925, to May 3, 1926.

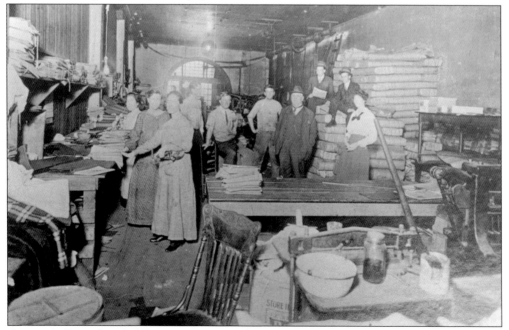

George A. Byrus founded the newspaper on July 30, 1897. In 1908, William Bowen, owner of the *Arlington Journal* from 1907 to 1920, posed with his staff amid the clutter of the dimly lit work room. The newspaper continued to serve Arlington until merging with the *Arlington Citizen* in 1957.

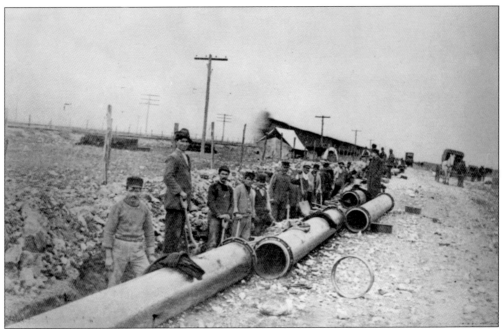

By the end of the first decade of the 20th century, Arlington was becoming a modern town with telephone, electric, water, and natural gas service. In this 1909 photograph, men working on the first natural gas line stand in the ditch with their shovels as a horse and buggy approach on the unpaved road.

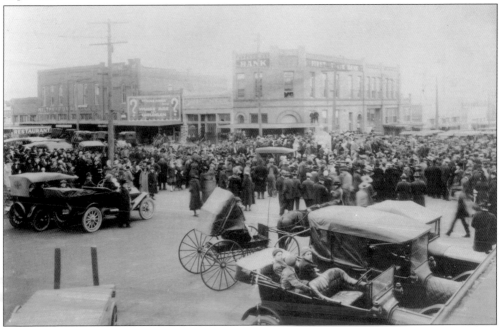

Progressing from a frontier outpost to a place with bustling businesses, gracious homes, and modern conveniences, Arlington in 1916 was no longer a small community but a proud town. Central Arlington boasted a population of 3,000 and a busy downtown with a bank, movie theater, restaurant, and furniture store.

Two

THE WAY WE WERE
DAILY LIFE

During the Depression, Arlington residents could not have predicted the sleepy town's rapid growth during the last half of the 20th century. After all, the cotton and market town's milestones during its first four decades were common to small developing communities everywhere. The first bank opened in 1904, the Masonic Home accepted retirees in 1921, and the city library first checked out books to eager readers in 1923. Daily life was devoted to friends and family affairs.

The boom in population and construction began during the 1950s. Changes were rapid. A traditional landmark, the mineral well, was deemed a traffic hazard and removed. Downtown Arlington disappeared—a casualty of a city planning philosophy that considered downtowns to be inefficient and promoted urban service clusters. Tom Vandergriff was elected mayor, a job that he held for a quarter-century. Vandergriff convinced General Motors to build an assembly plant in Arlington and supported the new toll road between Dallas and Fort Worth. In 1956, the old Waggoner ranch was transformed into the Great Southwest Industrial District, encompassing 6,800 acres and supporting 300 major industries. To secure water for growth, the city built Lake Arlington in 1957, and shortly after the work was completed, torrential rains filled the lake in an astounding 28 days.

Arlington, to its surprise, was transformed into a major vacation destination with the development of its Six Flags theme park. Not surprising was the influx of people moving to Arlington to work at the General Motors plant or take advantage of its strategic location between Dallas and Fort Worth. The population swelled from 7,692 in 1950, to 92,000 in 1970, to 162,000 in 1980, and to 380,000 in 2010. Arlington entered the 21st century re-energized with a solid economic foundation and increased community awareness of traditional values.

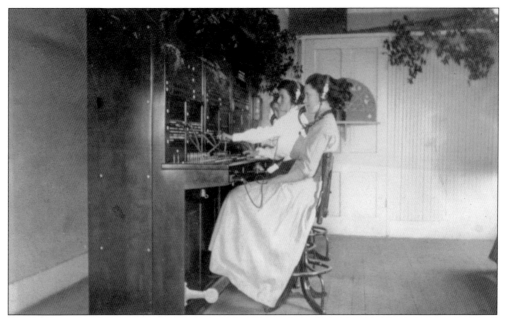

In 1911, a group of young women connected Arlington residents at the first Southwestern Bell switchboard, where Henry Williamson was the manager. At first, telephone companies had hired boys, whom they deemed to be generally impatient and discourteous when dealing with telephone customers, so companies began hiring young women as operators because they were composed and gracious. Arlington had 300 telephones in 1911 and 700 by 1936.

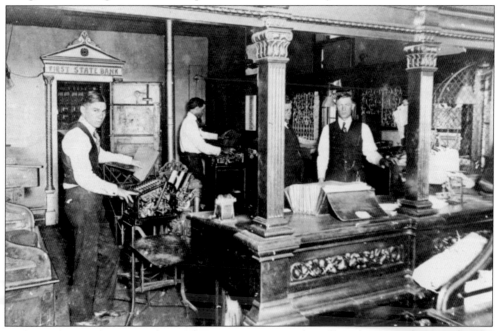

Dark paneling and ornate columns frame First State Bank staff in this 1919 photograph. The massive door of the vault, ornate grills, and "modern" office equipment promised security and efficiency to potential depositors. From left to right are Tommy Spruance, unidentified, Frank McKnight, and Dave Blackburn. The First State Bank opened in 1912.

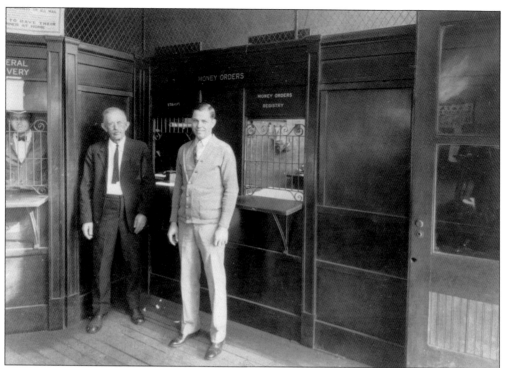

A post office played an important role in Arlington's history. It was because of a request to Postmaster Gen. James Marshall to change Hayterville's name to Johnson City that Hayterville was renamed Arlington to avoid confusion with nearby Johnson Station. That first post office was located in James Ditto's store. James Carter (center) was postmaster in this 1926 post office. Standing beside him is Royce Christopher. The man in the window is unidentified.

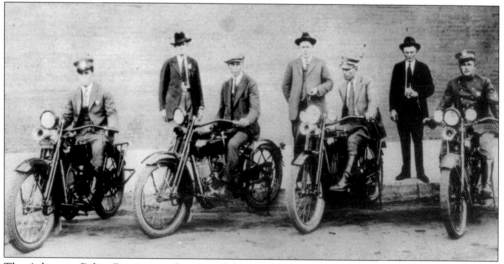

The Arlington Police Department has served the city since 1894. Over the decades, law enforcement changed from arresting cowboys who rode their horses into houses to enforcing the 10-mile per-hour speed limit established in 1911. A year later, the city purchased motorcycles for $290. During that era, police vehicles did not have radios. Officers would stop at their homes and call the station when necessary.

Reports from the battlefield and civilian efforts to support the war with rationing and war production dominated the news in 1918. Civilians showed their patriotic commitment in songs, movies, and dress. The military uniform worn by Lewis ? is a poignant memento of a time when people fought a war to end all wars.

In 1917, nine Arlington World War I soldiers gathered for a photograph. From left to right are (first row) Preston McKee and Tommy Spruance; (second row) Jess McKnight, Earnest Webb, and Smokie Kelley; (third row) ? Jetton, W. H. McKee, Ernest Morris, and Bundy Thompson. The war ended in November 1918, and the *Fort Worth Star-Telegram*'s headline shouted "Armistice Signed; World War Ends at 3 this Morning."

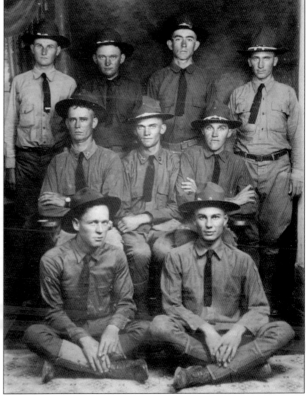

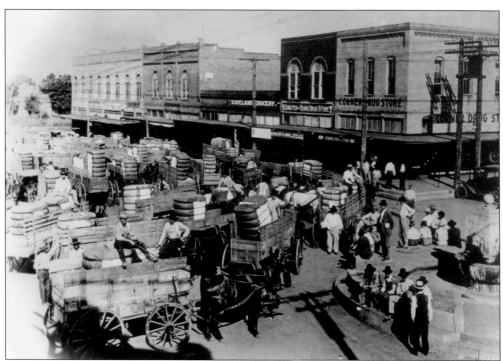

In 1916, cotton production was still high, and the farmers waiting near the mineral well (above) for the latest cotton prices could expect to earn enough for expenses and have a little left over. During the 1950s, other regions had replaced Arlington in cotton production. The Depression, drought with accompanying dust storms, and depleted soils had forced farmers off the land. By the 1940s, Arlington was evolving, although many citizens retained small-town values and resisted change. Slowly cotton gins disappeared. Randol Mill (right) had already burned by the 1940s after it had stood neglected and abandoned for over a decade.

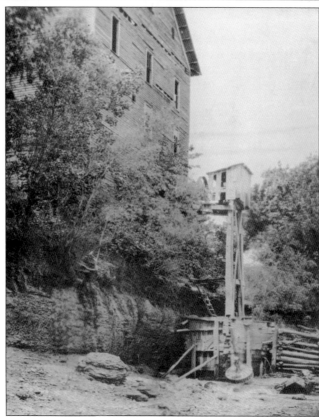

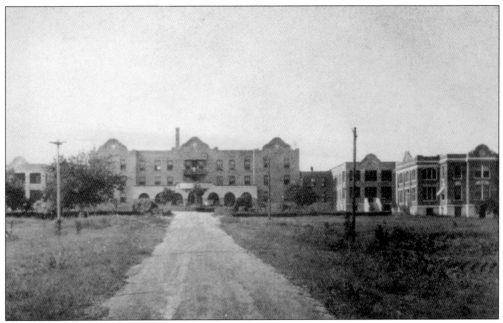

The imposing facade of the Texas Masonic Retirement Center is an impressive landmark surrounded by 100 acres of land with pecan trees. Masons' Grand Royal Arch Chapter opened the home in 1911. The orchards, gardens, and livestock provided much of the food used by the people living in the home. It is the only Masonic retirement home in Texas.

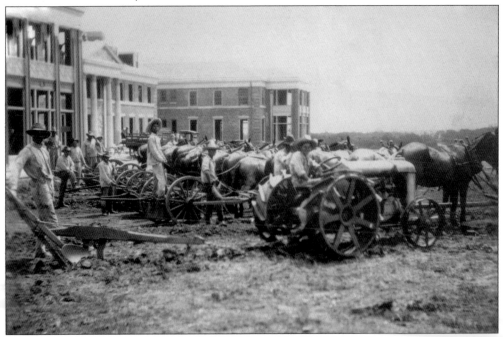

The Eastern Star Home was a retirement center built in 1924 for senior members of the Order of the Eastern Star. The facility is now closed, and former residents were moved to the Texas Masonic Retirement Center, but it was used as a temporary shelter after Hurricane Katrina in September 2005.

Berta Rose poses in front of her grandmother Martha Gibbins' home. James Gibbins purchased the land in 1863. The family added to the acreage and planted orchards, cotton, and wheat. In 1976, Berta Rose Brown and Margaret Leslie Rose May, great-granddaughters of James Gibbins, deeded 200 acres to Arlington for what is now called River Legacy Parks. (Courtesy Martha Rose May Martin.)

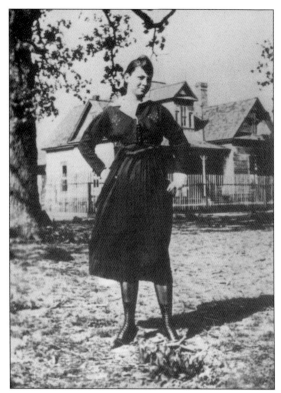

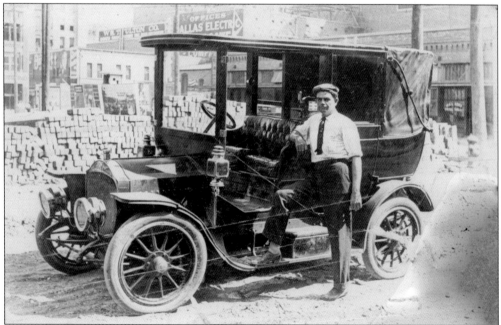

Pearl Rudd is standing next to his Ford Model T taxi. The 1911 Model T was an open car without a door for the driver. Passengers could count on traveling a top speed of 45 miles per hour in ideal conditions, and because of the gravity feed to the carburetor, traveling up steep hills in reverse if the fuel level was low.

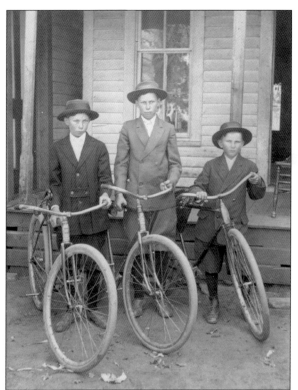

This 1912 photograph of brothers Charlie (left), Mike (center), and Roy Thompson hearkens to an ideal time in small-town America when young boys spent trouble-free days riding their bicycles on unpaved streets. They are dressed for church or school and are wearing the short pants prescribed for young boys.

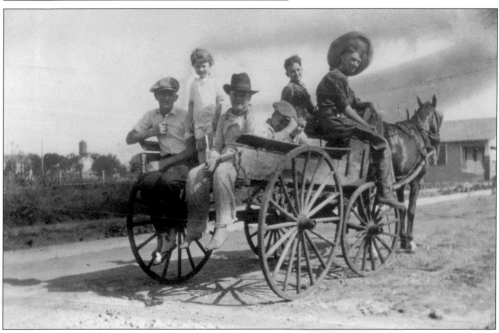

During the 1920s, horses and wagons were still part of the urban landscape. The young adults and families who had not yet purchased an automobile used horse-and-wagon transportation for pleasure and business. Taking a Sunday ride on Collins Street in 1921, from left to right, are unidentified, Jane Lowry, William Lowry, Donie Lowry, Jimmy Broderick, and James Lowry.

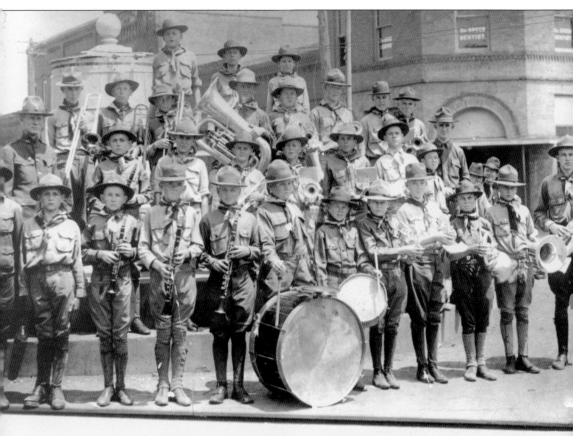

Arlington's Boy Scout Troop 1 band gathered around the mineral well in 1920 with their instruments. Dr. Greer was both Boy Scout leader and conductor. The band members are, from left to right, (first row) Frank Bird, Harold Tarpley, unidentified, Landreth Kirby, Pirkle Gibbons, Billy Shaw, Bill McCoy, unidentified, Paul Barnes, Ralph Knapp, and Paul Carter; (second row) Dr. Greer, Ralph Pulley, Wayne Pummil, Barton Parks, Charles McDonald, Victor Cooper, Harry Collins, Claud Aspaugh, and Mr. Wiley; (third row) Duff Kooken, Fred Lampe, unidentified, Sam Bennett, Howard Aspaugh, unidentified, Thurman Vaught, and unidentified; (fourth row) T. J Reeves, unidentified, and Billy Reeves. Scouting continues to be an integral part of the lives of youth living in Arlington.

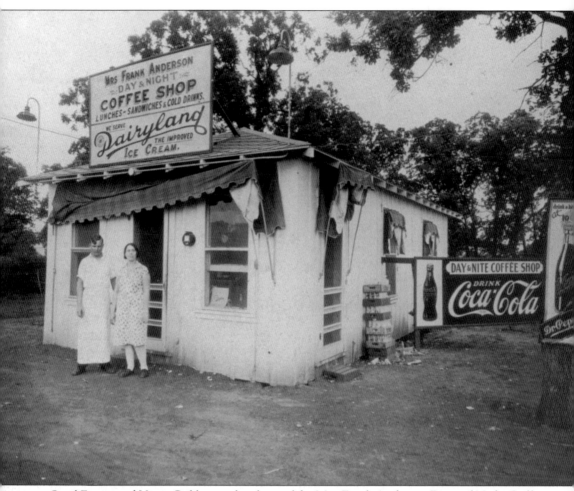

Orvil Frazier and Virgie Cribbs stand in front of the Mrs. Frank Anderson Day and Night Coffee Shop in 1930 under a sign advertising Dairyland, the improved ice cream. Located on the southwest corner of West and Division Streets, the restaurant served lunch, sandwiches, and cold drinks during a time when few were optimistic about the future. On Black Tuesday, October 29, 1929, the stock market collapsed triggering the Great Depression. Texas produced vast amounts of oil and gas and was slow to feel the effects of the economic crisis. Overproduction and falling prices soon combined with the worsening drought to force Texans to recognize that there was a crisis. Dallas and Fort Worth sponsored gardening projects and provided soup kitchens. Arlington's Works Progress Administration project buildings and Dalworthington Gardens, a social experiment sponsored by Eleanor Roosevelt, are reminders of that difficult time.

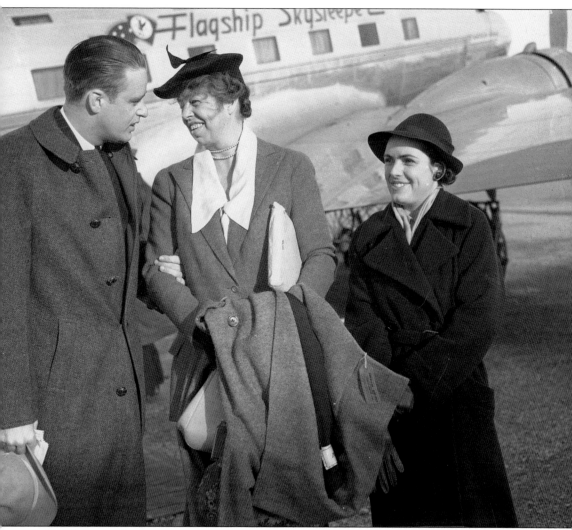

Dalworthington Gardens, an independent community surrounded by Arlington, was developed during the Depression when Eleanor Roosevelt decided to create an area with residential lots of two to four acres so that families could work at urban jobs and have small truck farms. Roosevelt chose the Arlington area after visiting her son, Elliott, who lived in Benbrook. From left to right in this 1938 photograph of a visit are Elliott Roosevelt, Eleanor Roosevelt, and Ruth Roosevelt (Elliott's wife). In 1934, the land was bought, and the Civil Works Administration cleared it of fences and trees, preparing to develop 80 sites. In 1949, the residents voted to incorporate into a town. Dalworthington Gardens is the only remaining subsistence homestead project that is still autonomous in Texas.

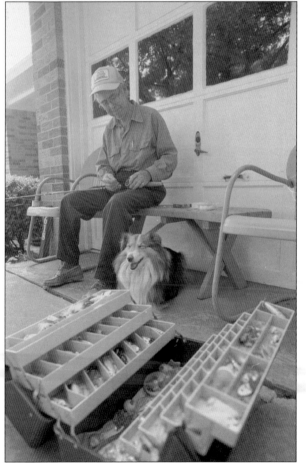

Dalworthington Gardens is surrounded by Arlington and Pantego but still maintains a rural atmosphere with gardens, horses, and single-family lots of no less than a half-acre. Local residents enjoy the luxury of raising livestock and participating in Future Farmers of America projects while being able to quickly visit Arlington's nearby malls and restaurants. The city will celebrate its 75th anniversary in 2011.

Surrounded by Arlington on three sides, Pantego was named after a Native American who befriended Fredrick Forney Foscue. Pantego's two square miles combine both rural and urban features, giving it the advantages of a small Texas town within reach of urban amenities in Dallas and Fort Worth. In 1991, Barney Lowe gets ready to take his dog, Benji, fishing at a nearby lake.

Early post offices in Arlington were located in a variety of places, including homes and general stores. Construction on the first freestanding post office began in 1939. During the Great Depression, Works Progress artist Otis Dozier painted *Gathering Pecans* on the interior wall to inspire public pride. The building on 200 West Main Street is now a national landmark.

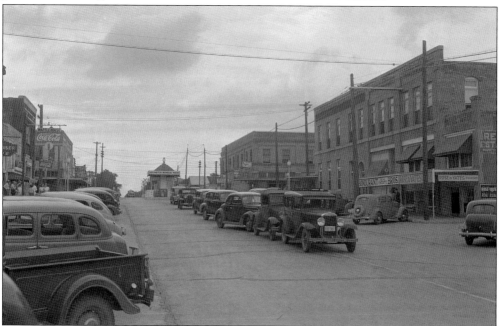

During the 1940s, Arlington felt that new construction was the key to its success. A view of downtown in 1940 showed new pavement and cars parallel parked along the sidewalks and down the center of the street. The mineral well, regarded by all as the heart of the town, is visible at the top of the street.

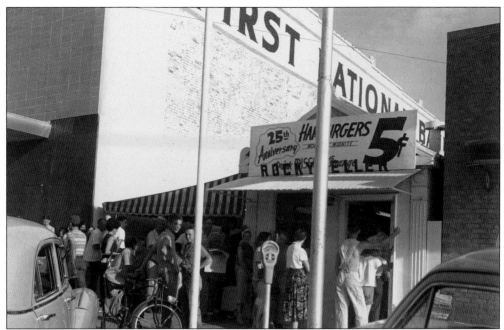

Young people who grew up in Arlington during the Depression and 1940s fondly remember Rockyfeller, where hamburgers were served from noon to midnight. The restaurant, located in a small building, was dwarfed by the nearby bank. On June 5, 1953, Rockyfeller celebrated its 25th anniversary by selling hamburgers for 5¢. This *Arlington Citizen News* photograph shows customers forming a long line outside while waiting for their turn to order.

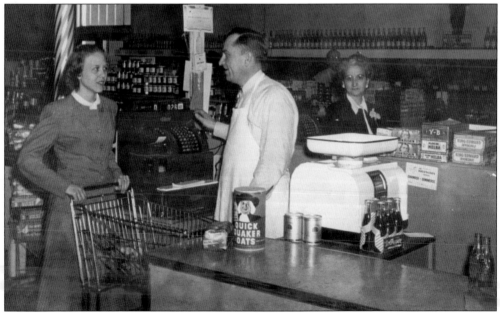

Luttrell Brothers Grocery and Meat Market, on Center and Abram Streets, featured frozen foods, a refrigerated fresh produce department, and a walk-in milk and cheese section. The store in this 1940s photograph was the leading independent grocer in north Texas. After the store closed its doors in 1954, Levine's Department Store occupied the building.

In 1942, Judeth Fitzhugh (front) and Mary Cecilia Cravens hold Arlington's first automobile license plate, issued in 1910. The first automobile arrived in Arlington in 1896, 10 years after Henry Ford built his first automobile in Michigan, but people continued to use horses as transportation and labor for another decade.

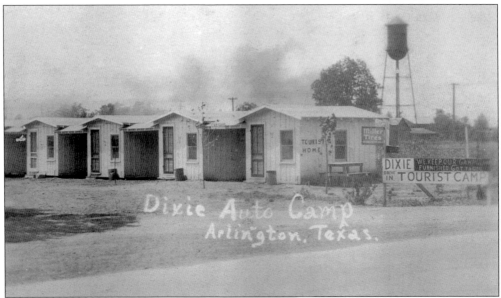

In 1940, the Dixie Auto Camp attracted motorists traveling on old Highway 80, now known as Division Street. The transcontinental highway passed through Arlington as it stretched from Georgia to California. Tourist courts made long distance travel within the means of the ordinary person' and served to create a tourist industry of restaurants, service stations, and local attractions.

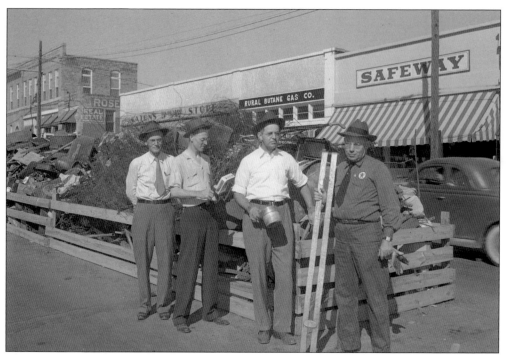

What did the U.S. Army need to fight the war with Germany and Japan? Wire fencing, barrels, and cooking pots. They are among the items gathered during a three-hour scrap metal drive on October 7, 1942. The War Defense Board melted down the metal to make tanks, ships, and munitions. Helping with the scrap drive, from left to right, are Mayor W. F. Altman, H. E. Caton, Alfred Brown, and D. S. Hood.

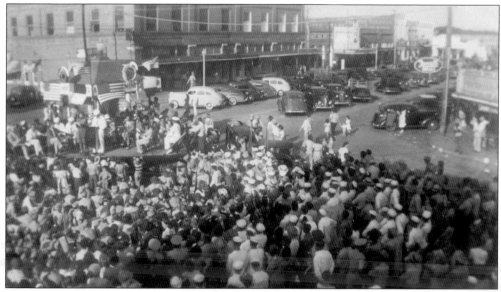

On December 7, 1941, while German armies were freezing before Moscow, America entered World War II after Japan attacked the American naval base at Pearl Harbor. Four days later, Hitler declared war on America. Of principal concern were issues surrounding war financing. War bond rallies, such as this 1943 event in Arlington, sold bonds to fund the war.

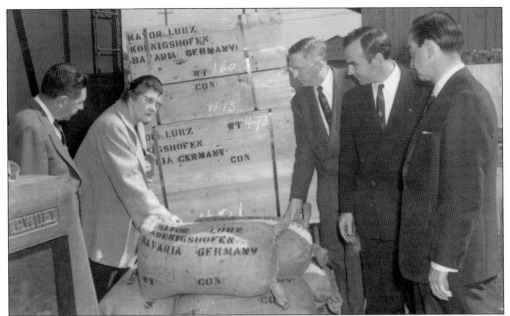

In 1952, Arlington came to the aid of Königshofen, a small Bavarian town about the same size as Arlington, after finding out that the town was overwhelmed by hundreds of refugees from Communist East Germany. Arlington citizens gathered up a railroad boxcar of supplies for Königshofen and shipped it on February 1, 1952. Mayor Vandergriff (right) and other city officials held a send-off ceremony for the first of many shipments.

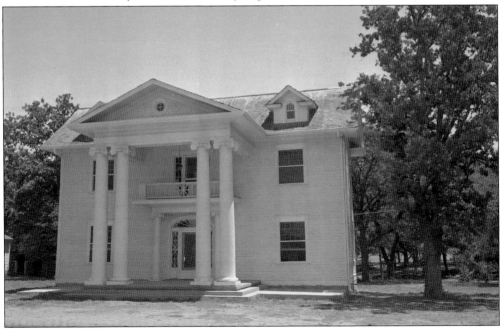

James Daniel Cooper built this gracious home in 1879 at Abram and Cooper Streets. After the Cooper family gave their home to the city, the city moved it to Meadowbrook Park. The house served as the city's library for many years. Later, the home became the Arlington Woman's Club meetinghouse, until a fire on Halloween in 1998 destroyed it.

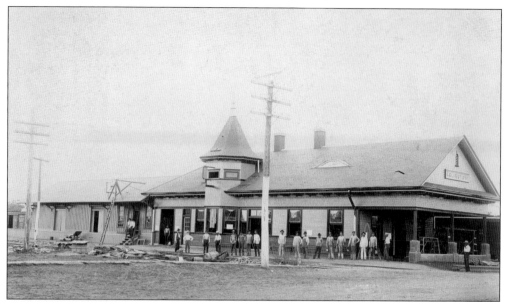

The Texas and Pacific Depot on Center Street was the heart of the city's shipping and transportation activity. Cotton farmers came to the station to find out what the latest cotton prices were and to ship their crops. Residents mailed letters from the depot for faster delivery. The depot was torn down in 1952. (Courtesy Martha Rose May Martin.)

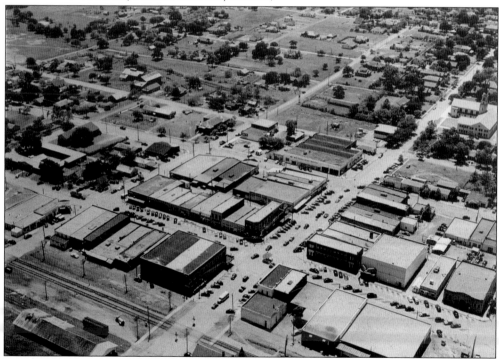

An airborne photographer captured a photograph of downtown Arlington at noontime during a sunny day in 1948. A decade later, many of the landmarks—such as the Texas and Pacific depot at center bottom and the mineral well in the intersection above the station—were gone. The open, tree-dotted areas at the top of the photograph became filled with businesses and residences.

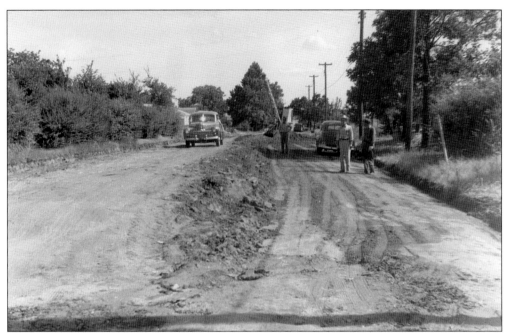

Progress has never been smooth, and neither was traveling along Collins Street in the 1940s. A population boom and use of automobiles required the city to tear up and repave dirt and gravel roads. Today Collins Street is a major north-south street that offers access to the newly constructed Cowboys Stadium and entertainment district.

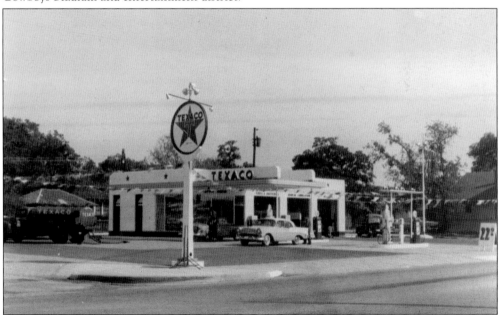

Prior to the late 1950s, bad roads limited cross-country travel. President Eisenhower changed that when he authorized the Federal-Aid Highway Act of 1956. The project was to build 41,000 miles of road capable of a 50- to 70-mile-per-hour speed limit. With gas at 24¢ a gallon, automobiles prices at $2,000, and interstate highways, drivers at the Texaco station on east Abram Street in 1957 were ready to tour.

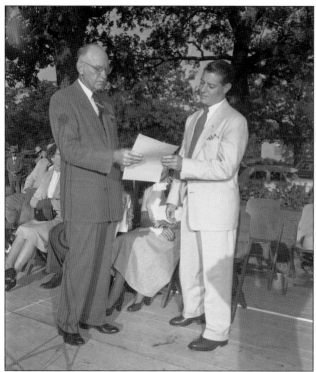

Arlington once again entered war when the Democratic People's Republic of Korea invaded the Republic of Korea in June 1950. The United States supported the Republic of Korea. When the conflict ended in 1953, many soldiers remained as prisoners of war. On October 8, 1958, Dr. E. H. Hereford (left) gave a citation of appreciation to returned prisoner of war Sgt. John Day. Day was imprisoned for almost three years.

Thirty-one women organized the Arlington Garden Club in 1926 at the First Methodist Church. In 1970, the club was awarded a $500 check for improving north Randol Mill Park. Taking a park tour, from left to right, are J. P. Plain, Nita Harmon, Rex Givan, Mrs. Robert Dooley, Mayor Tom Vandergriff, Marguerite Colyer, Barbara Lane, Tom Lane, Melvin Shanks, and Scott McCracken.

New president of the Arlington Chamber of Commerce Tom Vandergriff convinced General Motors that Arlington was the best location for their proposed assembly plant. A few years later in 1952, when the company held a ground-breaking ceremony for the General Motors Assembly Plant, Vandergriff was mayor. From left to right are James L. Conlon, Edwin C. Klotzburger, Tom Vandergriff, unidentified, and John E. Gordon.

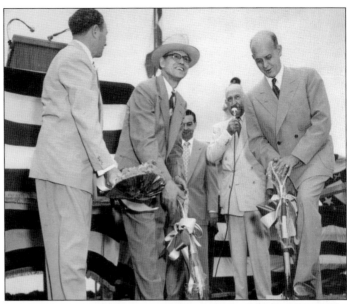

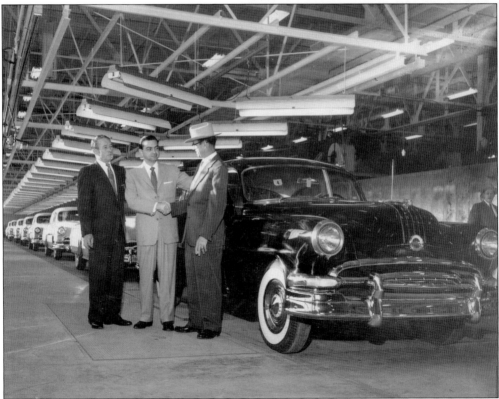

This black Pontiac Chieftain Deluxe sedan was the first car to roll of the assembly line at the General Motors plant in Arlington on January 6, 1954. The plant produced Pontiacs, Buicks, and, later, Oldsmobiles. Celebrating their achievement are General Motors division manager James L. Conlon (left), Mayor Tom Vandergriff (center), and Edward C. Klotzberger, the first Arlington plant manager.

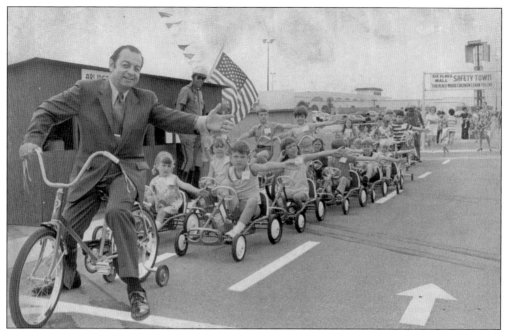

Mayor Tom Vandergriff was active in civic affairs. In 1971, Vandergriff correctly signals for a left turn while leading Arlington schoolchildren in a safety school at Six Flags Mall sponsored by the Arlington Police Department. Vandergriff served 26 years as mayor from 1951 to 1977, held one term as U.S. Representative from 1983 to 1985, and was elected four times as county judge of Tarrant County from 1991 to 2007.

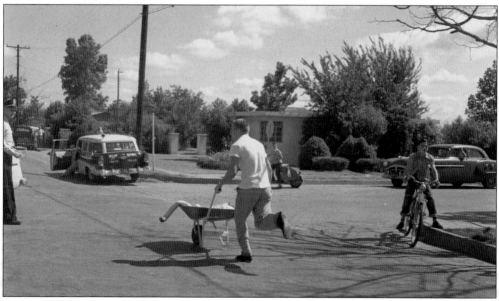

On May 26, 1956, a group of citizens supporting a new local hospital staged a demonstration. One group raced from the center of Arlington pushing a wheelbarrow with a fake accident victim to the site of the proposed hospital. At the same time, an ambulance took their victim to Fort Worth. It was faster to use a wheelbarrow than travel by ambulance to Fort Worth. Arlington Memorial Hospital opened in 1957.

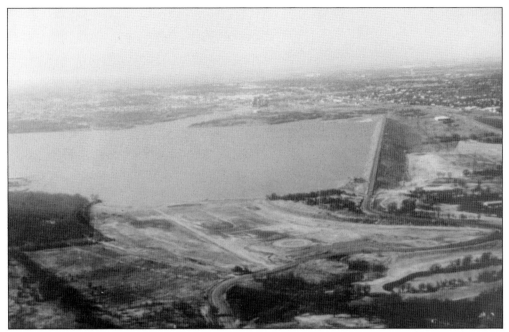

Arlington residents faced a water shortage during a long drought. In 1954, the city of 40,000 called a successful bond election for the construction of a lake. Construction began in 1957 and ended a year later when Arlington water superintendent Jack Cherry closed the last valve on the newly constructed dam.

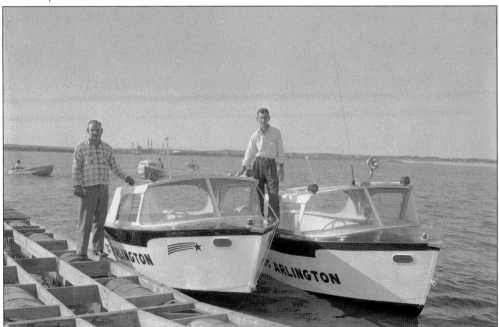

Initially called "Vandergriff's Folly" because it was believed that it would take two years to fill, torrential rains topped the basin in one month in 1957 leading to its second nickname, "Miracle Lake." Lake Arlington opened for fishing in 1958. These two patrol boats skippered by Troy Wommack (left) and J. D. Blanton went into full-time service on opening day.

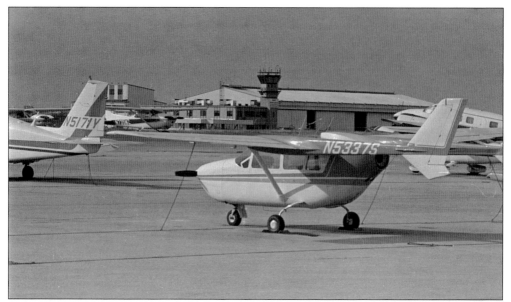

Arlington Municipal Airport, owned and operated by the city of Arlington, became a reality in the early 1960s after a decade of planning. Three hundred aircraft are based at the airport. The airport meets the aviation needs of visitors to the entertainment district, General Motors, and many other successful business enterprises.

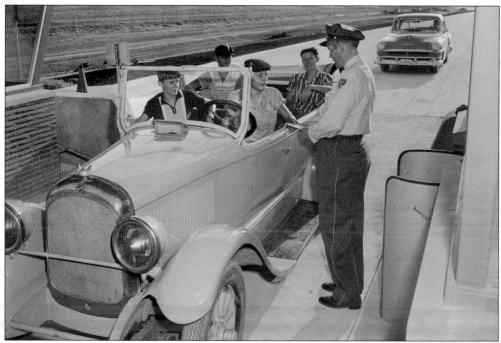

The new Dallas-Fort Worth Turnpike opened to traffic on August 27, 1957. It was the first toll road built in Texas. Commuters could shorten their drive between the two cities by 20 minutes. James Tolar, in his 1926 touring car, was the first motorist to leave Dallas on the turnpike. The passengers were Robert Devine in the front seat and, in the back, James Garland (left) and Dale Roberts.

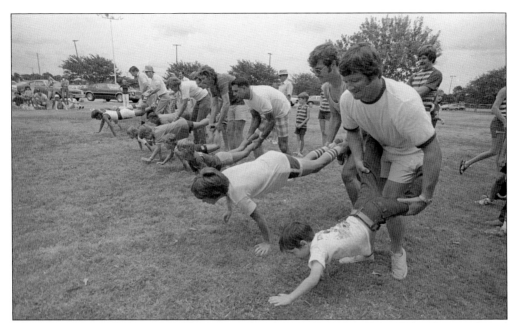

Arlington celebrated the national bicentennial and its own centennial in 1976 with a parade and old-fashioned fun. Bill Lawson and his son Mark (right) compete in the father-son wheelbarrow race. Earlier that day, Arlington hosted an Independence Day parade. Arlington's Fourth of July parades are the largest in Texas. Each year, spectators can count on seeing vintage cars, horses, floats representing local clubs, and high school marching bands.

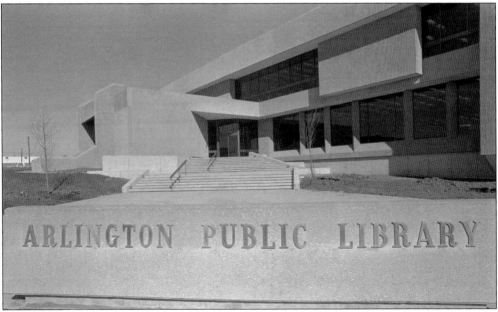

On January 20, 1973, the *Fort Worth Star-Telegram* headline accompanying this picture of the Arlington Public Library claimed "New Facility Caters to Un-bookish." Sculpture, paintings, albums, and tapes were available for patrons as well as books. The library was a big change from the first library in 1922, which was a wooden box containing 300 books in the First National Bank lobby.

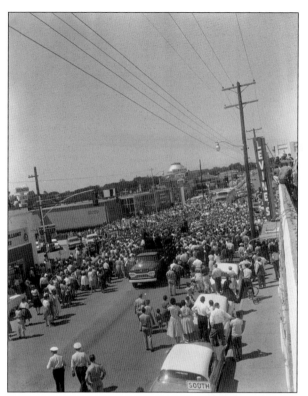

Democrat John F. Kennedy campaigned for president in Arlington on September 15, 1960, with his Texas running mate, Sen. Lyndon B. Johnson. This was the first presidential election in which Alaska and Hawaii participated, and it was also the first election in which both candidates for president were born in the 20th century.

John F. Kennedy leans down to shake the hand of a supporter during his September 1960 campaign visit to Arlington. Kennedy went on to defeat Republican candidate Richard Nixon. At the age of 43, Kennedy was the youngest president elected to the office.

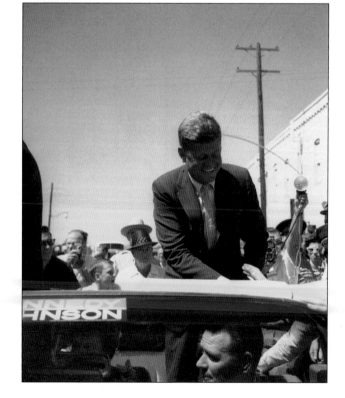

Elzie Odom made history in Arlington on Saturday, May 19, 1990. Odom was victorious in the Arlington City Council race against Joe Ewen and became the first African American elected to the council. Elzie and wife, Ruby, share a celebratory hug after the results were announced. Odom, a Texas native born in Burkeville and educated at Prairie View A&M University, later served as mayor of Arlington from May 1997 to May 2003.

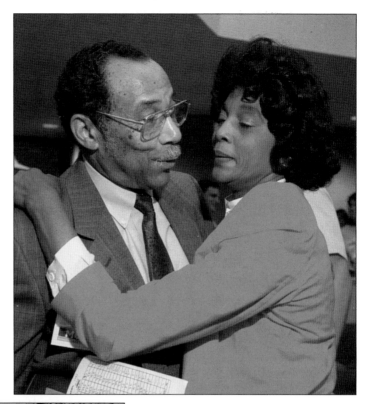

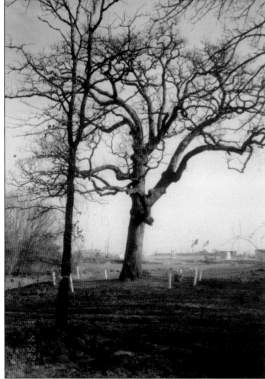

Arlington residents would make binding agreements beneath the boughs of this magnificent 500-year-old oak called the witness tree. The tree was transplanted in 1991 when it was in danger of being bulldozed to make way for a shopping center. Unfortunately, the tree only survived a short time until a storm stripped its leaves off. There is a memorial in a small park near where it grew.

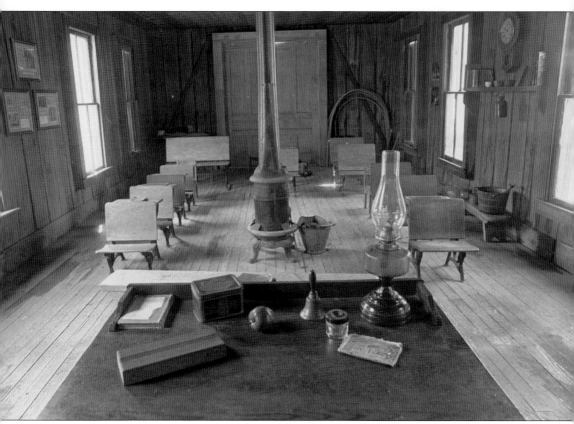

As Arlington moved into the future and old downtown Arlington disappeared, residents began remembering and preserving the past. The Arlington Historical Society restored the Jopling-Melear and Watson cabins and placed them in the Johnson Plantation Cemetery which the historical society managed and maintained. Local historian Dorothy Rencurrel lead the historical society's efforts to restore this temporary school, which was built after North Side School burned in 1909. The temporary school was no longer needed after North Side was rebuilt and so was sold for $150. Dan Dipert, school trustee, rediscovered the building in 1976. The historical society fully restored the school, refurnished the interior to look like an early-20th-century classroom, and placed it in the Johnson Plantation Cemetery. Later, the society moved the school and cabins to the Knapp Heritage Park, located on 201 West Front Street.

Three

HIGH STAKES
SIN AND SALVATION

Gambling, speakeasies, horse racing, and prostitution. Was this Las Vegas? Chicago? No, it was Arlington in the 1930s. The rapidly growing town was home to Arlington Downs Racetrack from 1929 through 1937 and Top O' Hill Terrace, a casino, brothel, and restaurant which was open 1930 to 1949. Both establishments flourished during Prohibition and for part of the Great Depression. They attracted the powerful, the notorious, and the famous. Bonnie and Clyde had permission to gamble at Top O' Hill if they left their guns in the car. John Wayne, Dean Martin, Frank Sinatra, Howard Hughes, and Sally Rand enjoyed the lavishly landscaped tea garden and late night entertainment with big band orchestras, roulette wheels, alcoholic beverages, and fine dining. At Arlington Downs, oil and cattle magnate William T. Waggoner entertained Will Rogers. Waggoner lobbied the state legislature to legalize pari-mutuel gambling, a system of betting in which the payout depends on the number and amount of bets placed, and, in 1933, the state passed such a law. Thoroughbred owners from across the country sent their horses by rail to compete at Arlington Downs and contend for large purses. The Texas Derby was known as the tryout for the more famous Kentucky Derby.

The vice did not go unnoticed. Texas and the rest of America were experiencing a reform movement that included fundamentalist preachers and their flocks, the Texas White Ribboners in the World Woman's Christian Temperance Union, the United Friends of Temperance, and the Anti-Saloon League. Institutions and individuals staunchly fought for enforced teetotalism to prevent the social damage and individual wreckage they believed to be the result of drinking liquor. In 1920, national and state governments ratified the 18th Amendment, which forbade the manufacture, transportation, and sale of alcoholic beverages. Popular support for Prohibition waned after the onset of the Great Depression, and in 1933, the 21st Amendment repealed Prohibition. But the reform movement had other successes, like support of rescue homes for fallen women, women's suffrage, child labor laws, and compulsory education for children.

As for Arlington, the Arlington Downs Racetrack changed to rodeos and automobile racing after the state legislature repealed the pari-mutuel laws in 1937. Ongoing religious opposition to the casino and a successful raid in 1947 by the Texas Rangers heralded the end of Top O' Hill Terrace.

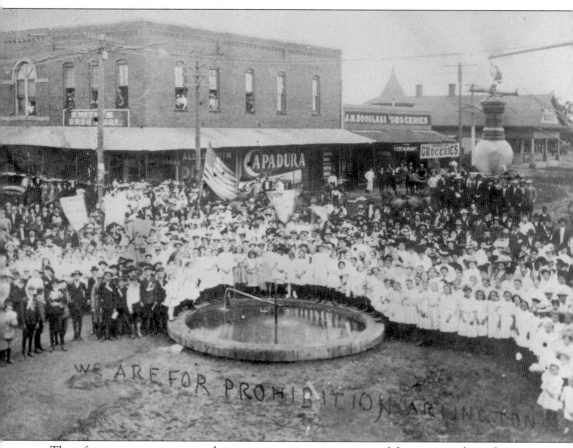

The reform movement attempted to cure corruption, poverty, moral depravity, and social injustice that had developed during rapid industrialization in America. Reformists supported rescue efforts such as the Berachah Home, struggled for women's suffrage, and campaigned for temperance. In this photograph, almost 1,000 people supporting Prohibition gathered about the Mineral Well at Main and Center Streets in 1902. Arlington men, women, and children carrying banners, waving flags, and singing Prohibition songs urged voters to support Prohibition and save homes and families from the evil influence of alcohol. Despite the show of solidarity, the local vote passed by only 19 votes. The issue of statewide Prohibition continued to divide Texans in a state with a local option law. Most of North Texas was dry, with only a few areas allowing liquor. Today the debate continues, with some cities and counties permitting alcohol sales and others banning it.

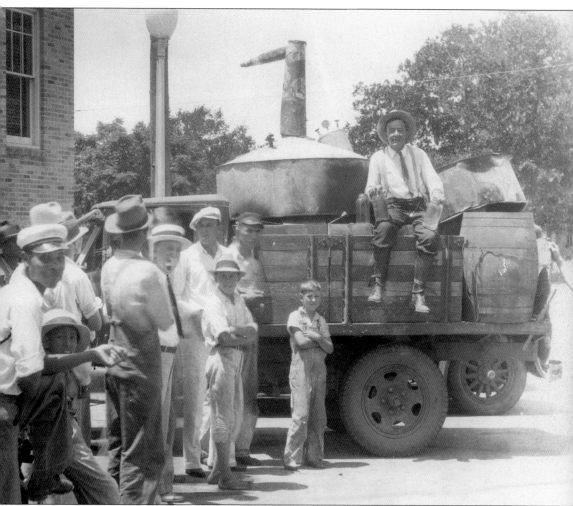

Constable Albert Austin proudly sits on the back of a truck loaded with a confiscated whiskey still in 1932. The 18th Amendment in 1920 prohibited the manufacture, sale, or transportation of intoxicating liquors. Despite the law, there was a public demand for alcohol, which created a black market where it was lucrative to operate an illegal still. Bootleggers and moonshine runners distributed the potent beverage at high risk and higher profit. In Tarrant County, entrepreneurs soon established speakeasies where well-dressed socialites danced to the music of Tommy Dorsey's Band and celebrated with champagne. Law enforcement struggled to halt production and distribution by locating hidden stills, catching bootleggers, and raiding saloons. Prohibition became increasingly unpopular during the Great Depression and was widely regarded as a failed social experiment. The ratification of the 21st Amendment in 1933 repealed the 18th, and alcohol sales were once again legal.

During the Great Depression, decorative wrought iron gates flanked by twin sandstone towers guarded the entrance to Top O' Hill Terrace, an opulent and notorious casino located in western Arlington. The owner, Fred Browning, and his wife, Mary, transformed a tearoom purchased from two elderly ladies into a luxurious destination with a tea garden, Olympic-sized swimming pool, horse barn, brothel, casino, and nightclub. The casino was a fortress, with three trapdoors in the walls that led to smaller rooms used to conceal gambling equipment in the event of a raid. As soon as the front gate sent a warning, the staff folded gambling tables up into the walls and rotated false walls to hide roulette wheels. High rollers and celebrities, including John Wayne, Howard Hughes, Jack Ruby, and Lana Turner, enjoyed trips to the casino in the evening after spending the day at nearby Arlington Downs racetrack. It has been rumored that during a busy weekend, over $250,000 would change hands at the casino. (Courtesy Arlington Baptist College.)

Shaded steps led to a lounge, restaurant, and living quarters for the Brownings and a hidden, two-level basement with escape tunnels. Guests slipped through a 50-foot escape tunnel and went up steps to an elegant tea garden. Lawmen would find them innocently sipping tea whenever they raided. Browning had the reputation of running a straight house that depended upon random outcomes rather than rigged games. (Courtesy Arlington Baptist College.)

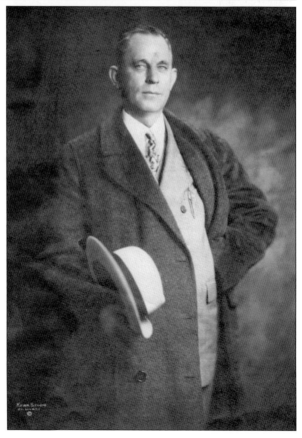

First Baptist Church of Fort Worth pastor John Franklin Norris, known as J. Frank, was a fierce opponent of Top O' Hill Terrace. He declared Top O' Hill Terrace a "blight" on Tarrant County. Norris participated in a raid on the gambling den that resulted in arrests and publicity for his cause. The Bible Baptist Seminary purchased the property in 1956 and became Arlington Baptist College. (Courtesy Arlington Baptist College.)

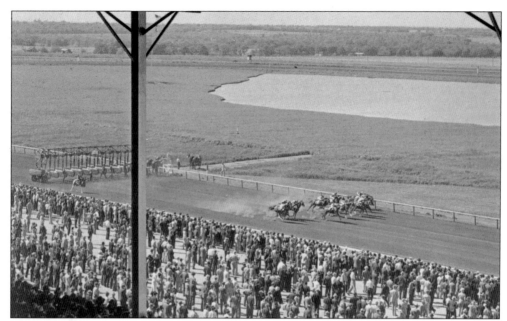

While the casino and brothel at Top O' Hill Terrace entertained the west end of Arlington, the east end enjoyed playing the ponies. Arlington Downs operated as one of only four tracks in Texas during the 1930s and was considered the classiest of the lot, offering the biggest purses. "For just about everyone, a day at Arlington Downs was a lot of fun," said Allen Bogan, a Texas horse racing historian. "It was a family outing."

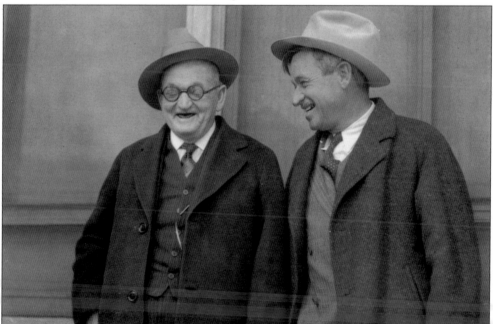

Arlington Downs was the vision of one man, William Thomas "W. T." Waggoner (left). Waggoner amassed his fortune with cattle before the discovery of oil on his ranch in Wilbarger County. According to author Sally Harrison, when humorist Will Rogers (right) visited the ranch with Waggoner he drawled, "I see there's an oil well for every cow."

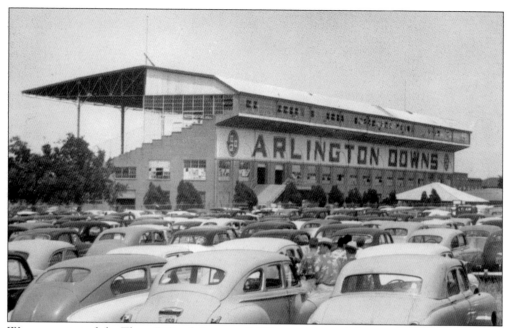

Waggoner started the Three D Stock Farm on 3,000 acres in east Arlington and in the late 1920s built a 1.25-mile racetrack, which opened November 1, 1929. In this 1945 photograph of Arlington Downs, Waggoner's Three D brand is clearly visible on the sign. Waggoner's stables included at least two offspring of the great thoroughbred racehorse Man O' War. Waggoner supposedly offered $1 million for Man O' War himself, but his efforts failed.

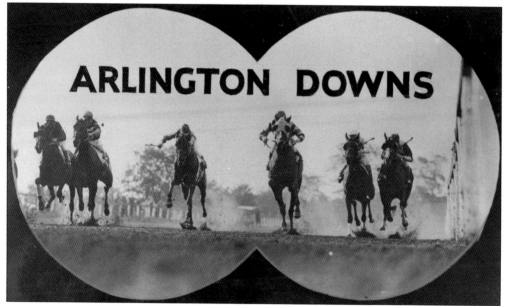

In 1929, pari-mutuel betting was illegal in Texas, so any wagering was done surreptitiously. Arlington mayor W. G. Hiett laid down the law at the track's opening by pronouncing, "The first man caught betting on the grounds will go to jail if I find out about it." Waggoner, for his part, lobbied tirelessly for the law to change. Finally, in 1933, Texas legalized pari-mutuel betting, and Arlington Downs took off like the horses in this undated photograph.

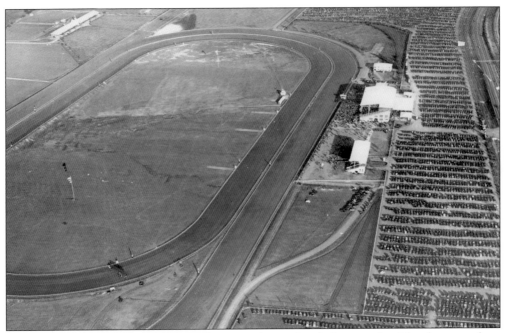

Visitors arrived at Arlington Downs, shown in this undated photograph, either by car or by a special bus chartered specifically to bring them from the interurban stop. Once on the grounds, spectators gawked at the 11,000-seat grandstand, 500-foot long training barn, luxurious clubhouse, and landscaped track with an artificial lake in the center. Other wonders included 600 stalls for visiting horses and a railroad spur that allowed horses to be brought right to the track.

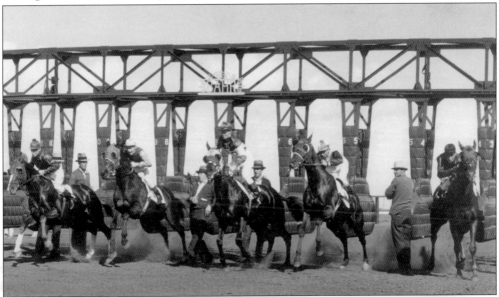

The Bahr gate, seen in this undated photograph of Arlington Downs, was a relatively new innovation. According to the May 15, 1930, *Daily Racing Form*, the Bahr gate "has been found to greatly simplify the problem of starting. It not only prevents horses from being kicked at the post but it gives each starter in the race sufficient room to begin well and does away with all talk of horses being held at the post by assistant starters."

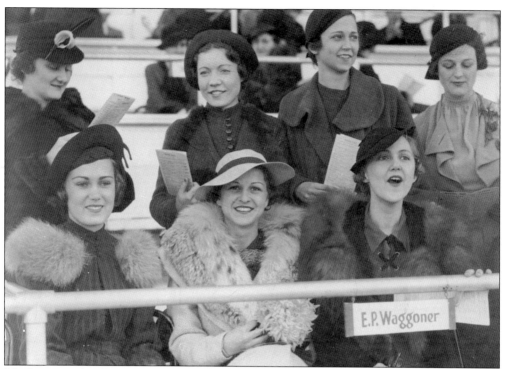

The horses and jockeys were not the only ones at Arlington Downs sporting colors. Clara Hood Rugel, the "Fashionist" of the *Dallas Morning News*, wrote an entire column on appropriate sportswear for Arlington Downs. "Witnessing a King's sport calls for correct dress," she wrote in 1929. Rugel suggested patterned tweeds and short box coats with raccoon collars as suitable for the races. These unidentified ladies at Arlington Downs are definitely following Rugel's advice in this undated photograph.

Jockey Buddy Haas, on Tiempo, won the sixth race at Arlington Downs on March 31, 1934, for a $700 purse. Standing next to him are Cleo Bearden, Glen Higdon, and Johnny Beech (right). Six years later at the Santa Anita Handicap, Haas rode Kayak II to second place behind Red Pollard on Seabiscuit at the latter's triumphant final race of his career.

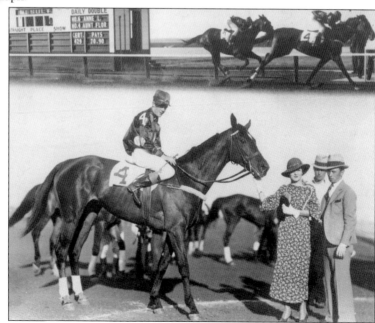

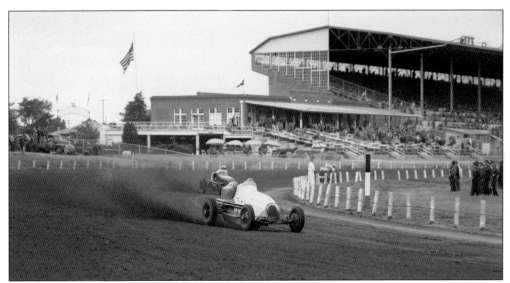

Not everyone was impressed with Arlington Downs. Local ministers like Rev. W. T. Rouse of Arlington Baptist Church strongly condemned pari-mutuel betting. Under pressure from church groups and Gov. James V. Allred, the Texas Legislature repealed pari-mutuel betting in 1937. Afterward, Arlington Downs hosted events like rodeos and automobile racing. In this photograph, driver Ted Horn leads Duke Nalon in an American Automobile Association (AAA) Championship race on November 2, 1947.

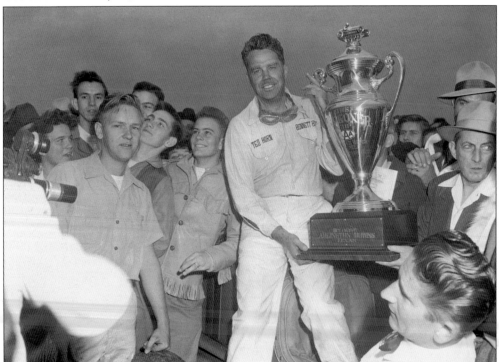

Horn, averaging over 90 miles per hour in the 100-mile race, won before a crowd of 25,000. He is shown here holding the Waggoner trophy. Horn went on to win the AAA National title in 1947, but died from crash injuries the following year in Illinois.

In 1950, MGM crews came to Arlington Downs to film an AAA race for the Clark Gable and Barbara Stanwyck movie *To Please a Lady*. Although neither Gable nor Stanwyck came to Arlington for the race, Gable inscribed this program cover "To the race fans in Texas." Reviews of the movie found the plot and dialogue lacking, but the racing footage excellent.

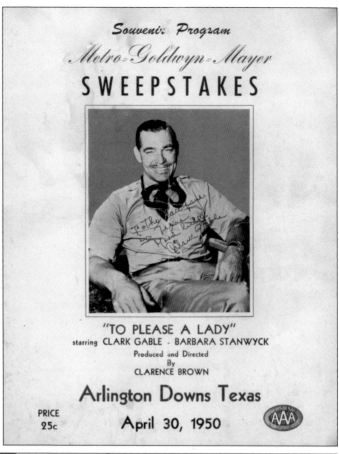

Souvenir Program

Metro=Goldwyn=Mayer

SWEEPSTAKES

"TO PLEASE A LADY"
starring CLARK GABLE - BARBARA STANWYCK
Produced and Directed
By
CLARENCE BROWN

Arlington Downs Texas

PRICE
25c

April 30, 1950

AAA

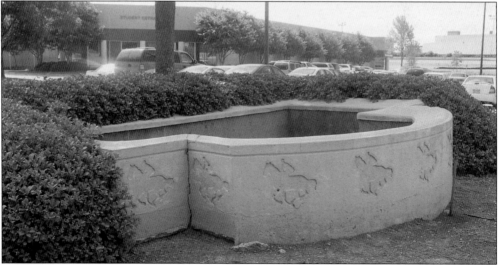

In 1958, Arlington Downs was razed to make room for the Great Southwest Industrial District. The only physical remnant of this once-great track is a horse trough located at the northeast corner of Division Street and Six Flags Drive. Visitors can still see the carvings of jockeys on horseback racing around the outside of the trough. (Courtesy Evelyn Barker.)

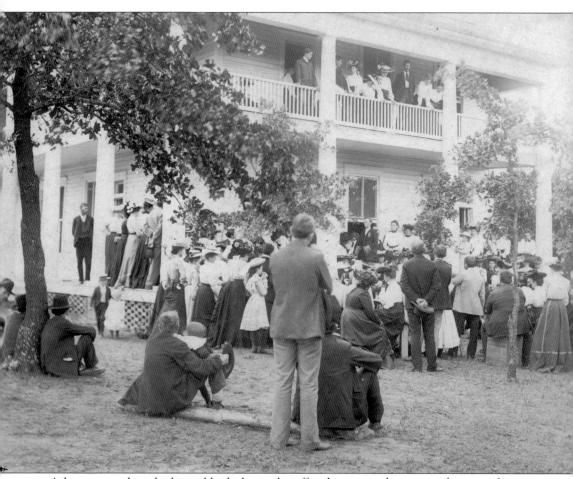

Arlington may have had its wild side, but it also offered a unique chance at redemption for erring women. On May 14, 1903, a crowd of over 300 people attended the dedication of the Berachah Industrial Home for Girls, a home for the homeless and a friend to the friendless. The home, located in a wooded area that is now part of the University of Texas at Arlington campus, welcomed pregnant single women and those who had no home and needed care. Rev. James Upchurch and his wife, Maggie May Adams Upchurch, established the home to help save young women from the perils of prostitution and drinking. The home used strong fundamentalist moral codes and rigid religious rules to save those who violated the strict Victorian sexual code. Over the next 32 years, the home helped some 3,000 women.

ANNNIVERSARY NUMBER.

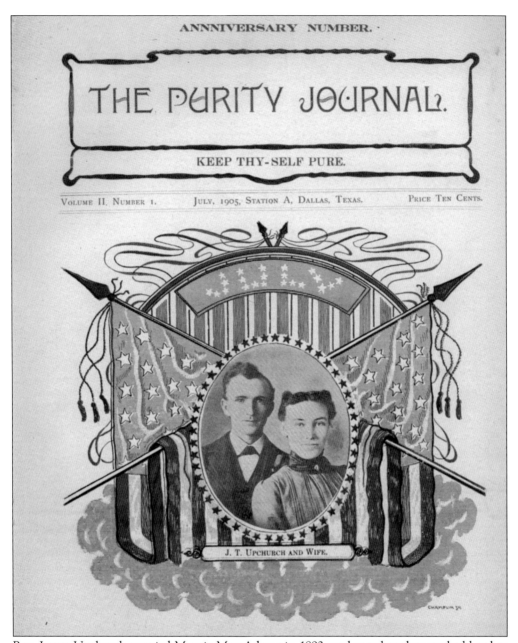

THE PURITY JOURNAL.

KEEP THY-SELF PURE.

VOLUME II. NUMBER 1. JULY, 1905, STATION A, DALLAS, TEXAS. PRICE TEN CENTS.

J. T. UPCHURCH AND WIFE.

Rev. James Upchurch married Maggie May Adams in 1892, and together they worked hard to share their deep faith with the less fortunate. They are shown here in this 1905 illustration. They initially served in Waco's red light district and attempted to rescue young women from a life of prostitution, but they quickly discovered that they needed to have a place to nurture and train the young women in skills such as printing, nursing, gardening, and home economics. Berachah Home was dedicated in 1903 and continued to flourish until 1935, when financial support dwindled due to the Great Depression and the death of some of the home's donors. The Upchurches' daughter and her husband, Rev. Frank Wiese, continued the ministry to the unfortunate by opening an orphanage on the grounds, but it failed in the 1940s. Reverend Upchurch died in 1950, and Maggie followed in 1963.

Reverend Upchurch never reviled the erring girls and women, but instead attempted to change the environment that led to their downfall. He did not regard the babies born to unwed women in this photograph as illegitimate. Berachah Home required single mothers to keep their babies and did not allow adoption. Upchurch maintained that 75 percent of the women who remained at the home for a year remained upright.

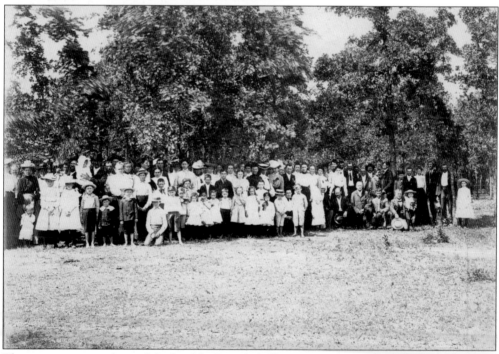

The group posing in the cool shade of the Berachah Home grove during the dedication ceremony in May 1903 contributed a total of $35 before they left that evening. The daylong ceremony included a dinner, tour of the home, and a sermon on rescuing "fallen women." Upchurch was a master fundraiser who knew how to use the hard luck stories of the women seeking admittance to gain financial support.

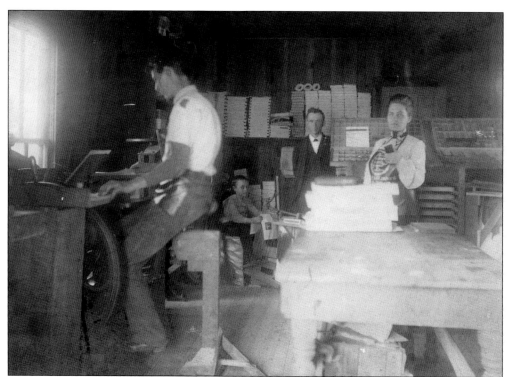

Berachah Home training was designed to improve the women's prospects and support the home's mission. Rescued women spent the day learning trades such stenography and printing. The printing office of the home printed the *Purity Journal*, religious tracts, and pamphlets. Reverend Upchurch is looking at the camera while Brother Fering operates a machine. The woman and child are unidentified.

The back cover of the July 1905 issue of the *Purity Journal*, illustrated Mary Howitt's poem, "The Spider and the Fly." The *Purity Journal*, a publication printed at the Berachah Home, campaigned against vice that led to the downfall of women. The poignant stories of redemption and salvation and reports of work done in slums and shelters promoted the home and raised funds.

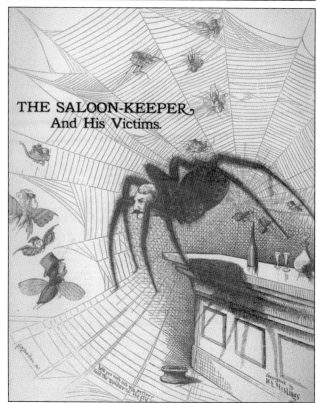

THE SALOON-KEEPER, And His Victims.

Reverend Upchurch had a vision of a grove with five buildings for the home. He found his grove in Arlington, Texas, and soon built Berachah Home. It began with one building on seven acres and grew to 19 buildings on 75 acres by 1930. The grove (above) soon became a place to enjoy moments of solitude. Berachah Home maintained a garden where the young mothers could learn how to grow their own food and become self reliant. Produce from the large garden was an important addition to their daily fare. The tractor (below) was essential to the Berachah Home's success.

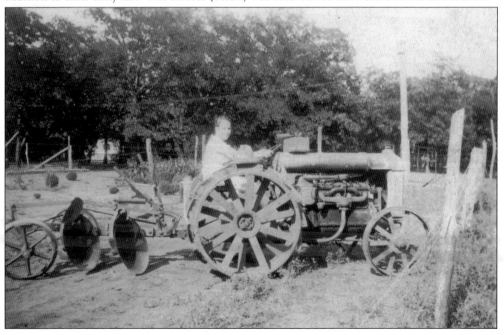

Four

PENCILS AND PULPITS
COMMUNITY BEDROCK

Arlington schools and churches serve their community as preservers of heritage and tradition They also reflect the changes going on in society because of growth, war, integration, and social movements.

Public education in Arlington did not have a promising start. In his book *Transitions*, author Gerald Saxon notes that in 1895 the Arlington school district had an enrollment of 365 students, but only six teachers. As a result of the poor educational opportunities, Arlington merchant Edward Emmett Rankin proposed opening a private school in the town. The school, which served students from elementary to secondary grades, was called Arlington College and was the origin of today's University of Texas at Arlington (UT Arlington).

The first permanent public school building, South Side, opened in 1904 and taught all grades from elementary through high school. The first high school, Arlington High School, opened in 1923 at the corner of Cooper and Abram Streets. The school moved down Cooper Street to a new building in 1955, but the original high school building remains as a part of the UT Arlington campus.

Regarding places of worship, many denominations had built churches in Arlington by 1893. "Arlington is a social and moral center," said a December 29, 1887, *Dallas Morning News* article, which also mentioned that "there has not been a fight in the town" over the Christmas holidays. Newspapers often ran stories of tent meetings and revivals and tracked the comings and goings of ministers from the pulpits. In addition to worship, churches established schools like Arlington Baptist College and St. Maria Goretti and provided charity to those needing a hand through institutions like the Berachah Industrial Home for Girls or today's Mission Arlington.

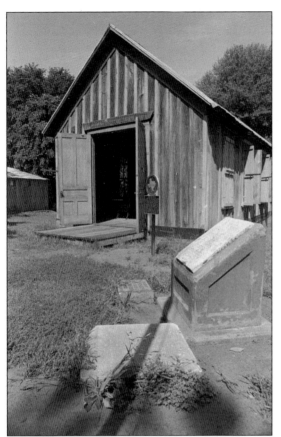

In the eastern half of Texas where lumber was plentiful, wooden structures were common. This school was built after a 1909 fire destroyed Arlington's North Side School. After a brick replacement for North Side was completed, the wooden schoolhouse was moved from its original location. It served as both an office and a shed for many years, until it was moved to Knapp Heritage Park on Front Street in 1977.

Arlington had over 350 schoolchildren in 1897, the year this photograph of Arlington Public School students was taken. Notable faces in the photograph include future Arlington mayor William H. Rose (fifth row, second from left); teacher Eliza Hayter, daughter of Rev. Andrew S. Hayter, who is one of the men credited with naming Arlington (fifth row, third from left); and Arlington photographer A. J. Mahanay (fourth row, far left). (Courtesy Martha Rose May Martin.)

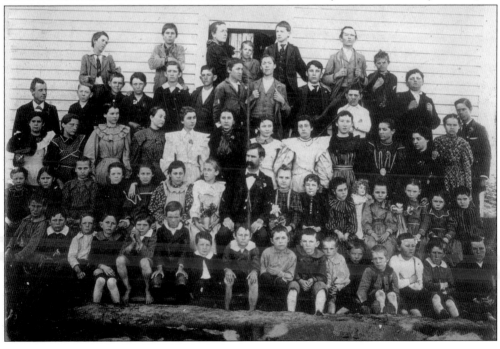

With Arlington still rural, six months of free public schooling started in November so that children could help bring in the harvest. If parents wanted to send their children to school in September, they had to pay tuition. These 1908–1909 teachers were probably paid about $50 a month.

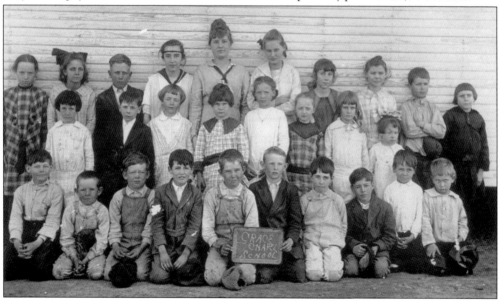

Proving that one's day could be worse, the December 30, 1927, *Arlington Journal* tells of a special event at Grace Chapel School, a community located around present-day eastern Arkansas Lane, shown here in 1917. "The three weeks' rat killing contest, conducted by the teachers of the Grace Chapel school, came to a close last Monday. The contest resulted in the killing of 1,019 rats and 124 mice."

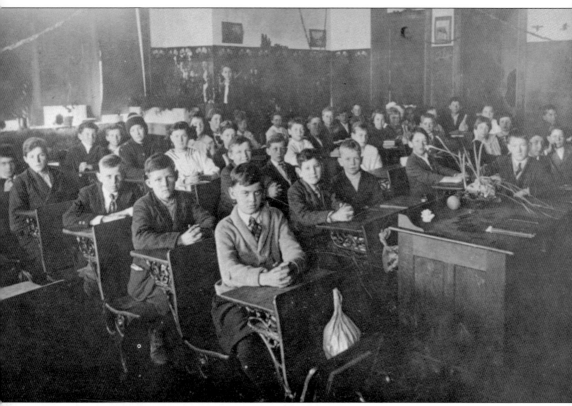

This class of third and fourth graders met in South Side School in 1917 under the tutelage of Ella Virginia Day (standing in back). Day graduated from Arlington in 1911, and then attended Carlisle School before earning her teaching certificate in 1913. She eventually left teaching to become the first female banker in Arlington. She died in Arlington on August 12, 1985. South Side burned down in 1933, but a new building was dedicated in its place in 1936. The building eventually became Dunn Elementary until the school moved to a new location in 1973. The original South Side building was eventually torn down.

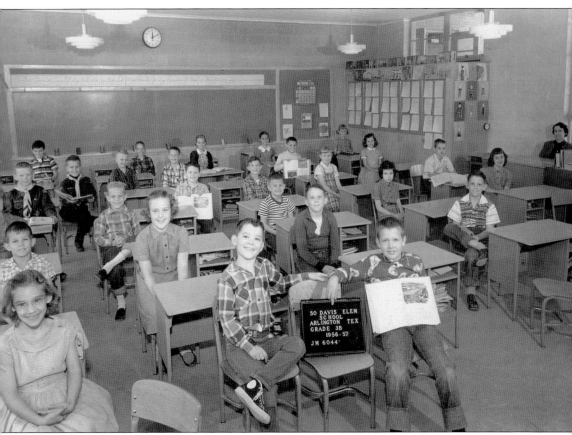

Although 40 years separate this 1956-1957 South Davis Elementary class from the third graders of South Side, much remains the same: bright young faces, rows of desks, and the teacher in the back. South Davis, named for its location on Davis Drive, opened in 1955. With the exception of alternative elementary school Turning Point, South Davis is the only Arlington elementary school not named for a person. In 2001, the school board considered changing the school's name to align it with the other schools, but met strong opposition. "The community went buck-wild crazy," said then South Davis principal Erma Nichols in a 2005 *Fort Worth Star-Telegram* article. The motion was tabled indefinitely. William Gunn, son of then school board member Floyd Gunn, sits on the front row to the right of the sign. (Courtesy Floyd Gunn family.)

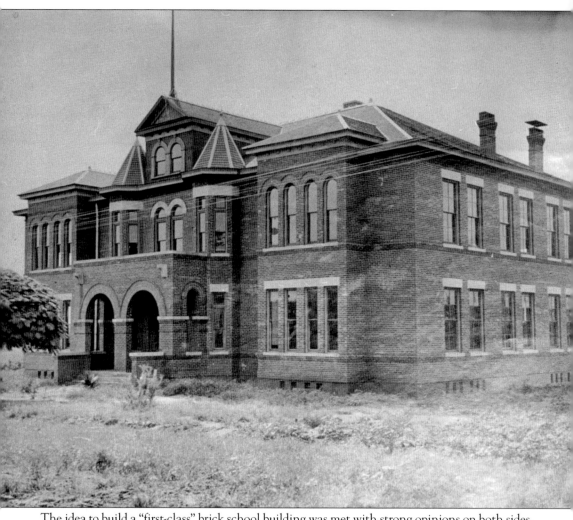

The idea to build a "first-class" brick school building was met with strong opinions on both sides. David Sibley noted in a 1901 *Arlington Journal* article, "Without a good building we cannot realize good schools." Others thought the old wooden structure was good enough. Those for a new building won, and South Side opened in 1904, teaching all grades of students.

Boys frequently had to leave school to work, so graduating classes were often comprised of only girls. These five young ladies are South Side's first graduating class in 1905. Their names are Clara Deer, Pearl Turck, Bama Nichols, Annie McElreath, and Mae Smith (order unknown). According to the Arlington High School Alumni web page, not until 1908 did a graduating class include boys.

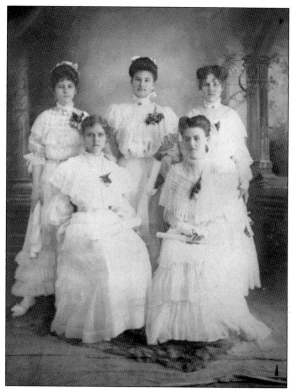

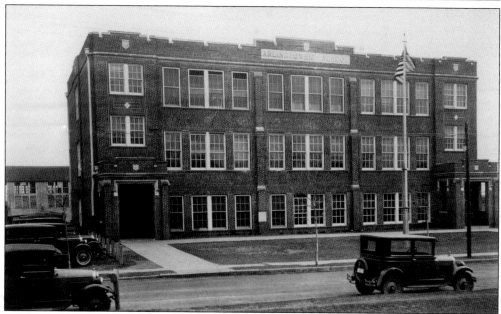

As the town grew, the need for a separate high school became apparent. Thus the city built Arlington High School near the corner of Abram and Cooper Streets in 1922. It is shown here in 1928, a few months before construction started on a wing to each end of the building. In 1956, the high school moved to a new building a few blocks south where it remains today. The original building is now part of the UT Arlington campus.

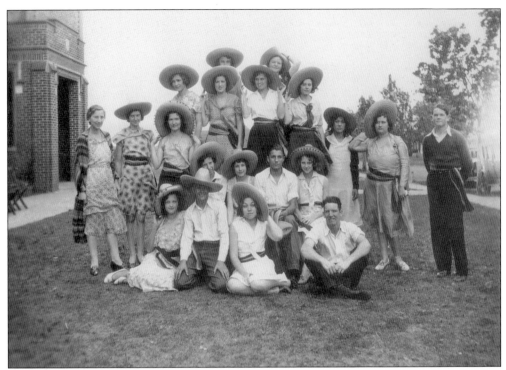

The female students of the Don Quixote Spanish Club do their best femme fatale imitations in this 1930–1931 image taken in front of Arlington High School. Teacher Dora Nichols (standing, far left) taught in Arlington between 1927 and 1958. She was active in many community efforts and was a noted artist. Nichols Junior High was named in her honor. She died in 1986.

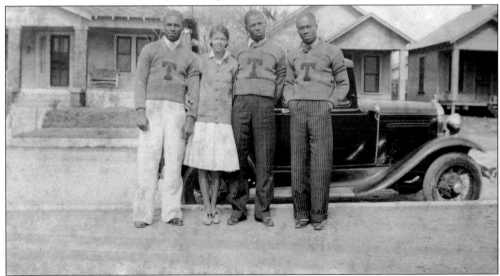

To attend high school, African American students in Arlington were bussed about 13 miles to I. M. Terrell in Fort Worth. This practice continued until Arlington schools integrated in 1965. The three unidentified students in this undated photograph attend Terrell High School. (Courtesy of the Tarrant County Black Historical and Genealogical Society Collection, Genealogy, History, and Archives Unit, Fort Worth Public Library.)

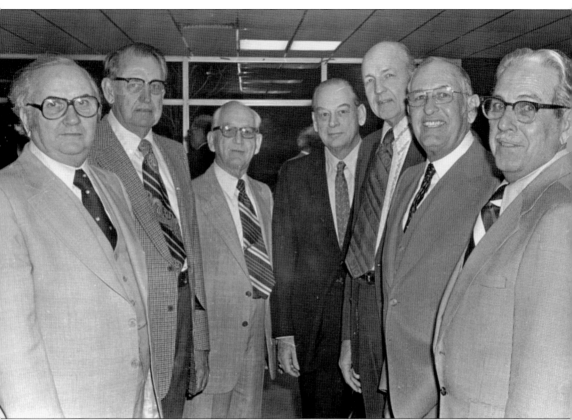

Floyd Gunn (far right), a former Arlington Board of Education president, is the namesake for Gunn Junior High and was a proud supporter of the school. Grandson William Gunn Jr. recalls, "My grandfather went to lots of football games with Charles Young [namesake of Young Junior High] and they would sit together on the Gunn side for half the game and on the Young side the other half, cheering for both teams. After retirement he would often get up early and go to school and sit through classes and eat lunch with the students in the cafeteria—anything he could do to help encourage the students to do their best." Others in the photograph are, from left to right, James Martin, Ross Wimbish, Charles Young, Guy Hutcheson, Roy Wood, and O. D. Shackelford. Each of the men has an Arlington school named after him. (Courtesy Floyd Gunn family.)

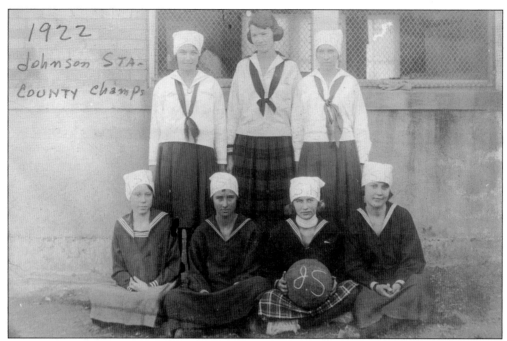

School athletic teams have always inspired pride and loyalty. Here is the Johnson Station girls' basketball team, 1922 district champions. The girls have J.S.H.S.—Johnson Station High School—hand-lettered on their kerchiefs.

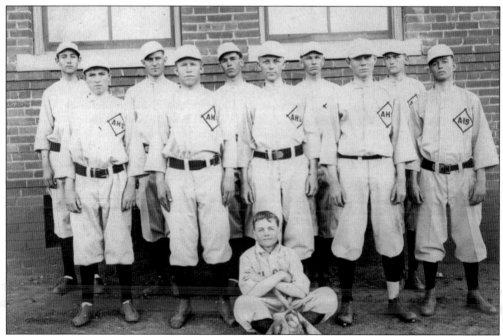

"The base ball craze has struck this good old town full in the face and ball games are as numerous as fleas on a dog's back," wrote the *Arlington Journal* in July 1902. It got so popular, in fact, that some small towns banned playing baseball on Sundays to preserve the sanctity of the day. These boys represent Arlington High School in 1913.

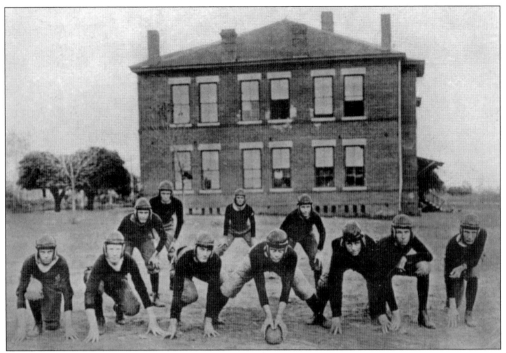

According to the *Arlington Journal*, football was first played in Arlington in 1904—a game between Carlisle Academy and Oak Cliff. "The public may expect," said the *Journal* in 1904, "something extra in the way of broken limbs, cracked skulls, and bruised and battered faces." Here, the South Side team looks ready to play (but woefully underprotected) in 1920.

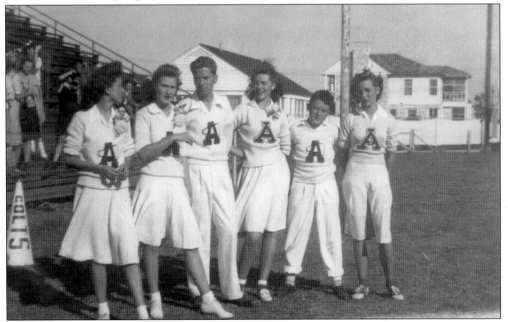

What are sporting events—especially football—without cheerleaders? Shown here from left to right are 1943–1944 Arlington High School pep leaders Virginia Sycock, Ruth Knox, Donald Stephens, Janie Decker, Shorty Hogan, and Marie Arnold.

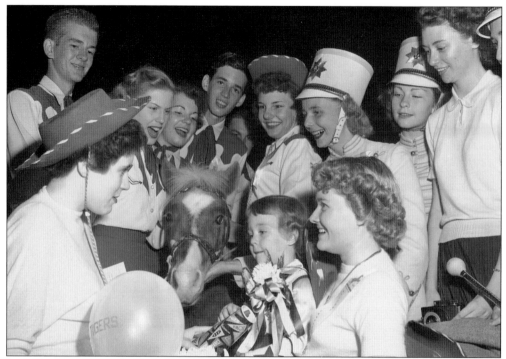

In 1950, the Arlington High School Colts got a real-life mascot—a Shetland pony—as a gift from Tom Vandergriff. Named Little Arlie, he is shown in this October 27, 1951, photograph with Patsy Kelly (left, in hat). Kelly, a polio victim, received an autographed football that night. The girl on Little Arlie's right is Pamela Workman, the cheer section mascot and daughter of Arlington coach Mayfield Workman.

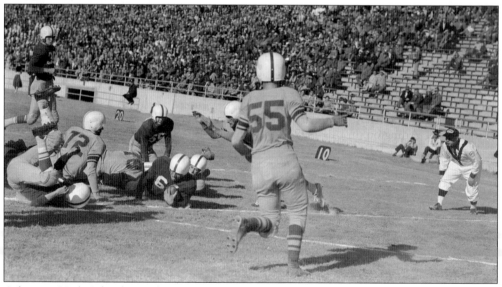

Arlington High School won the city's first (and only, as of 2010) state football championship in December 1951. Clutching the football is Cecil "Rusty" Gunn, a 190-pound all-state fullback. Gunn made the game's only touchdown, giving Arlington the 2A state title over Waco La Vega at Baylor Stadium.

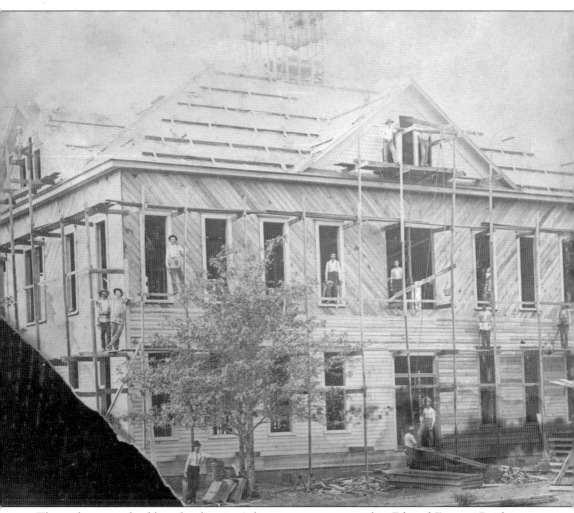

The early years of public schooling in Arlington were so poor that Edward Emmett Rankin, a local merchant, convinced public school coprincipals Lee Morgan Hammond and William M. Trimble to start a private school in town. Called Arlington College, the school opened in fall 1895 and taught children from primary through secondary grades. The college is the forerunner to today's UT Arlington. In this 1895 photograph, workers are constructing the school's first building, later called Fish Hall.

After seven years of struggle, the grounds and facilities of Arlington College were turned over to James McCoy Carlisle for Carlisle Military Academy, which opened September 16, 1902. This 1903 photograph shows Carlisle and his wife, Julia, in their garden. Behind them is Carlisle's mess hall.

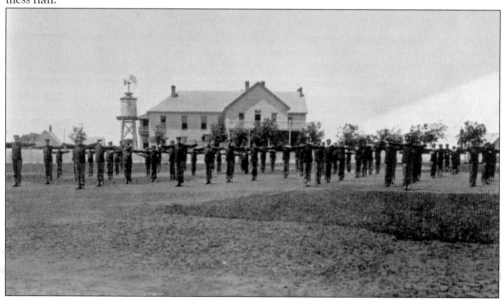

Billing itself as "A High-Grade Preparatory School for Manly Boys," Carlisle Military Academy emphasized academics, military training, and discipline. These 1906 cadets are probably wearing their "blues and grays"—a blue shirt and cap with gray trousers—as they demonstrate their exercises.

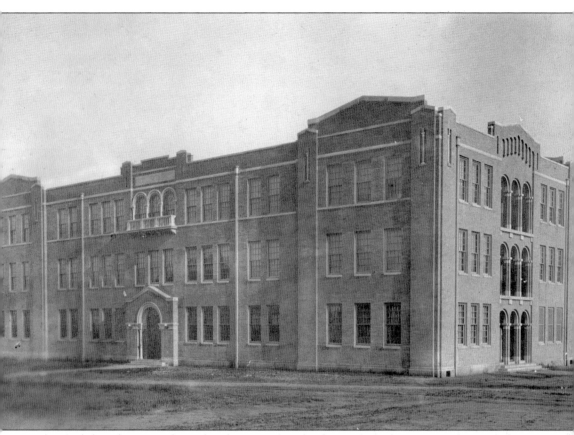

After Carlisle Military Academy closed in 1913, the school went through two name changes before becoming Grubbs Vocational College in 1917. At that point, the school stopped being a private elementary and secondary school and became what is traditionally thought of as a junior college. Named for Vincent Woodbury Grubbs, the college was under the direction of Texas A&M. This photograph shows the Grubbs administration building, now known as Ransom Hall, in 1919. Grubbs College, whose mascot was the Grubbworm until 1921, gave birth to one of the school's most enduring traditions: *The Shorthorn* campus newspaper. The first publication of *The Shorthorn* in 1919 ran 48 pages sized 6 by 9 inches. It changed to a newspaper format in 1921.

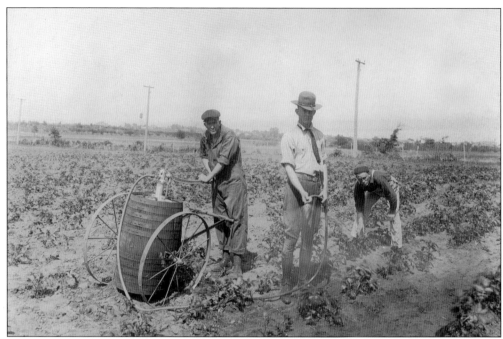

Grubbs Vocational College focused on vocational education, specifically agriculture, horticulture, floriculture, stock raising and domestic arts and sciences." In this undated photograph, unidentified students spray potatoes on the campus farm.

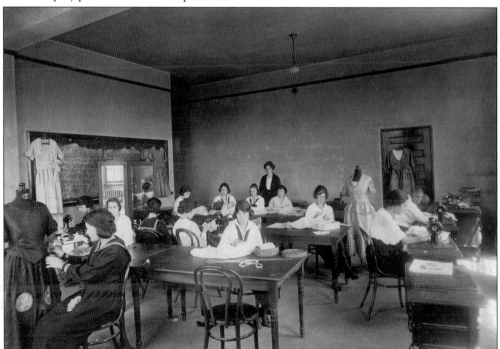

Grubbs College had two tracks: agriculture for men and domestic arts for women. Women in this 1917 photograph are practicing their sewing skills. During World War I, students would sew for the Belgian relief effort and the Red Cross. Grubbs closed in 1923.

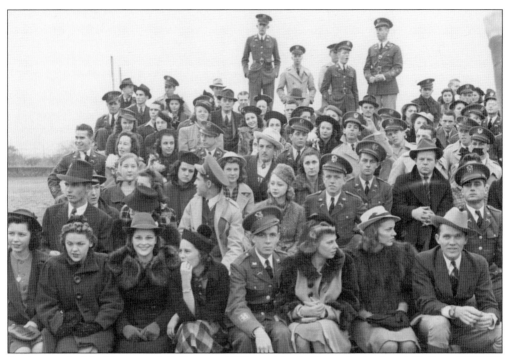

Replacing Grubbs Vocational College in 1923 was North Texas Agricultural College (NTAC), still under the auspices of Texas A&M. NTAC grew tremendously during the 1930s, doubling its enrollment of 821 students in 1929 to 1,632 students in 1939. The NTAC students shown here in 1939 are enjoying a football game against archrivals John Tarleton Agricultural College.

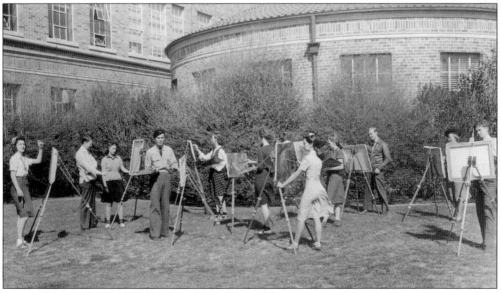

During World War II, NTAC art professor Howard Joyner (second from left) taught camouflage classes in the Roundhouse building, seen in the background of this 1946 photograph. The Roundhouse was built in 1928 as a livestock judging ring, then later used as a slaughterhouse before the art department took it over. In 1963, the building was used for history department offices. The Roundhouse became a planetarium in 1981 and is still used for that purpose.

The NTAC Exchange Store or PX, shown here in 1948, sold school supplies, military uniforms, and accessories. It was also a popular gathering place for students and teachers in need of refreshment between classes.

In 1949, NTAC became Arlington State College (ASC). One of the high points for ASC came in 1956 and 1957, when the football team won back-to-back Junior Rose Bowl titles. Here, majorette Barbara Barnhill of Arlington and All-American quarterback Jon Schnable of Mexia celebrate ASC's 1957 championship. After graduating from ASC, Schnable played for Rice University in 1958 and 1959.

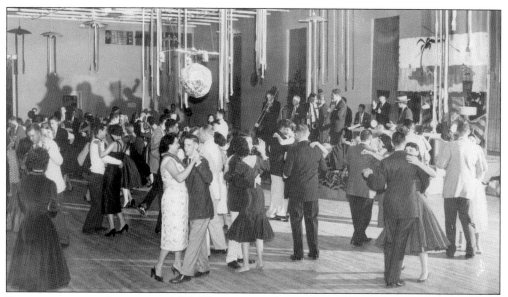

Dances were a popular event at ASC. There were welcome dances, homecoming dances, sorority dances, military dances, holiday dances, after-game dances, and even Thursday dances. Formal dances, like the one the undated photograph above, featured traditional dances like the waltz and foxtrot. As the big band era faded, young people started dancing in styles that did not require a partner. The television show *American Bandstand* had a huge influence on dance styles, and in the early 1960s, popularized the Twist—the dance ASC students are performing in the undated photograph below.

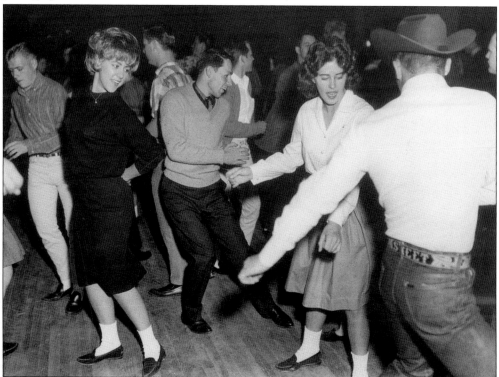

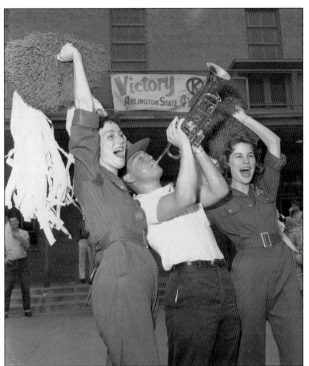

On April 27, 1959, the Texas Legislature passed a bill allowing ASC to become a four-year institution. According to an April 1959 *Dallas Morning News* article, when the news reached campus, "The blare of just about every siren and car horn in town and the vigorous pealing of bells brought classes to an end at 2:00 p.m." Here, ASC cheerleaders Charla Blount (left) and Jerry Carter (right), flank bandsman Ken Priksyl to celebrate the day's event.

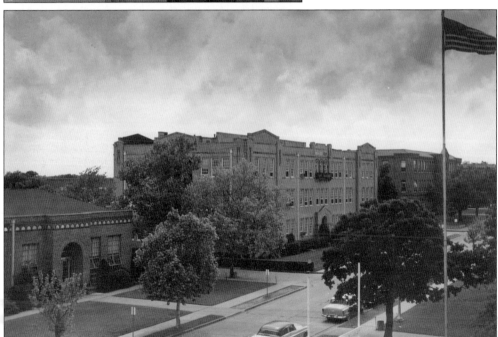

The November 1965 *Alcalde* reported that when Gov. John Connally signed a bill transferring ASC from Texas A&M to the University of Texas, ASC student body president Lynn Little shouted into a telephone, "He's signed it. It's over. We're teasips now!" Here, the campus is shown in the late 1950s or early 1960s. The university changed its name to the University of Texas at Arlington (UT Arlington) in 1967.

In 1951, ASC students elected the Rebels as the new mascot. Afterward, it was natural for other motifs of the Confederacy to appear around that theme, as can be seen in this undated photograph. Band uniforms sported a large Confederate flag and "Dixie" became the fight song. After the campus integrated in 1962, the rebel theme became a decade-long point of contention and one of the most divisive issues the campus ever faced.

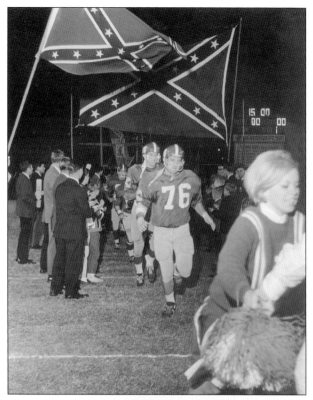

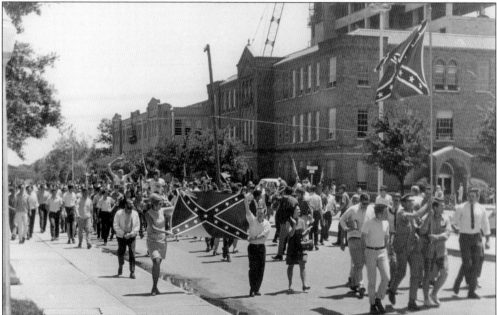

In spring 1968, UT Arlington Student Congress passed resolution No. 132, which called for the end of the rebel theme. This prompted a backlash in which letterwriters called the members of the student congress "un-American" and destroyers of school tradition. On April 30, 1968, students staged a peaceful protest against the student congress's decision to abolish the rebel flag.

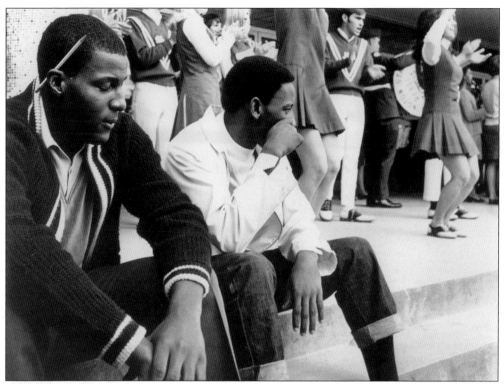

The turning point in UT Arlington's rebel theme conflict came in October 1969, after a fight broke out at a pep rally over the display of the rebel flag. Three people were knocked to the ground, and students burned miniature Confederate flags. The event left the campus shaken and led some to decide the fight to keep the rebel theme was no longer worth it. Here, two unidentified students attend a pep rally in the 1960s.

The rebel flag flew outside the UT Arlington student center until Student Congress decided to permanently remove it. Here, the flag comes down for the last time on June 30, 1968. On January 29, 1971, the University of Texas System Board of Regents voted 7 to 2 to abolish the rebel theme, effective June 1, 1971.

After the rebel theme was abolished, UT Arlington students voted on a new mascot. The options included Mavericks, Toros, Rangers, and Hawks. After Mavericks won the votes, students chose an image of a horned horse to represent the mascot. Here, Maverick, the horse with horns, poses with Sam Maverick, the human counterpart, and an unidentified cheerleader in 1971. The horned horse concept did not last, mainly because horses—horned or otherwise—were not allowed on the field of Arlington Stadium. So a Maverick became solely Sam Maverick, loosely based on the historical Samuel Augustus Maverick, a Texas land baron and legislator. In 2007, students voted to replace Sam Maverick with a new Maverick incarnation, a blue and white horse—unhorned. Students held an election in fall 2007 to name the horse, and the name Blaze came out on top.

Religious organizations established gathering places around the campus, providing both spiritual and social opportunities for students. Here, on the ASC campus, are United Christian Fellowship House leaders Linda Bounds, Rev. L. E. Philbrooke, and David Bennett (right) in October 1956.

Religion and education also intertwine at the Arlington Baptist College (ABC), situated on the site of the former Top O' Hill Terrace casino. Bible Baptist Seminary, the forerunner to ABC, purchased the property in 1956. Of note in this photograph is Isaac Green (far left) of the seminary graduating class of 1957. At a time when Arlington State College was still segregated and would be for five more years, the seminary had already lowered racial barriers.

Early Arlington Methodists met in homes or places like Schults's Lumber Yard until 1885, when they built a frame church. The first brick church, called Centenary Methodist Episcopal Church, was built in 1906, but was destroyed by fire in 1918. Work immediately began on a new building on top of the existing foundation. In 1948, the quarterly conference of the church changed the name to First Methodist Church of Arlington, Texas. As Arlington grew, so did the church, and the congregation made plans to start expanding the facilities. Right before the construction contracts were completed, disaster struck the church a second time on November 23, 1954, when an electrical fire burned the sanctuary down. Services met in the Arlington Theater, now home of Johnnie High's Country Music Revue, until a new sanctuary, featuring three stained glass windows from the previous sanctuary, was consecrated in February 1956.

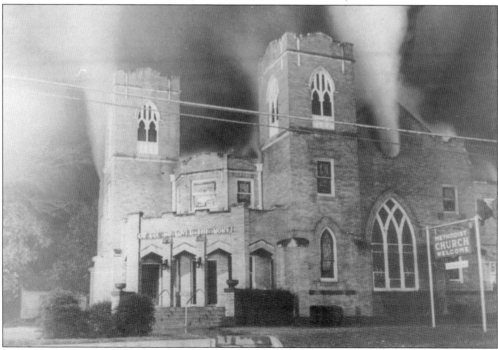

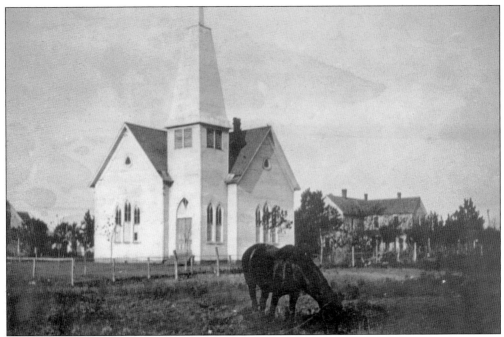

The first Presbyterian church was completed in 1891 at what is now the corner of Abram and South Pecan Streets, but before it could even be used, a lightning strike burned the church down. The congregation immediately recommenced construction and dedicated the church in November 1891. This photograph was taken in 1900. In the mid-1950s, the church built a new sanctuary on South Collins Street.

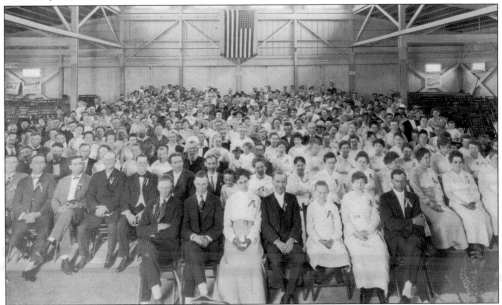

The Berachah Tabernacle, shown here in May 1919, was part of the Berachah Home complex founded by Rev. James and Maggie Mae Upchurch in 1903. The Berachah ministry was devoted to helping out-of-wedlock mothers. This photograph was probably taken at the church's anniversary celebration. The ministry ceased operations in 1940.

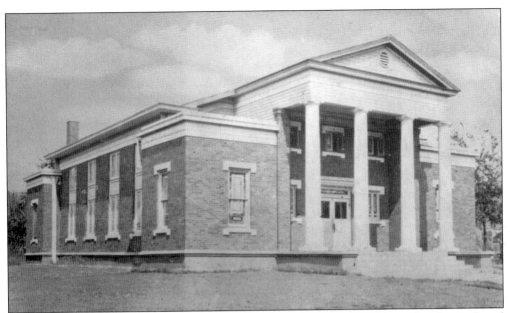

First Baptist Church, shown here in 1921, evolved from Baptist congregations that first gathered at Johnson Station. The church seen in this photograph was built in 1917, but it burned in 1944. The congregation met at the original Arlington High School building until a new sanctuary opened on Easter Sunday, 1947. First Baptist Church founded Mission Arlington in 1986.

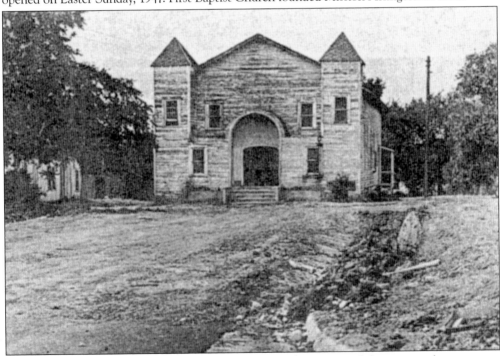

One of Arlington's African American communities, The Hill, boasted the commanding structure of Mount Olive Baptist Church, established in 1897. Built around 1912 at the terminus of West Street, the frame structure was a pillar of the African American Community and hosted the black Masonic lodge. The church later moved to its present location on Sanford Street.

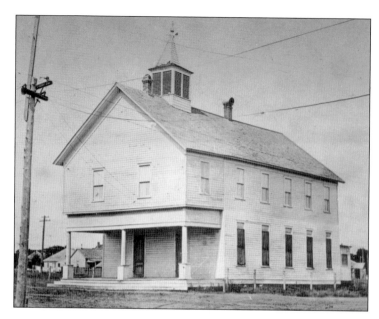

The First Christian Church traces its origins in Arlington to 1882, when traveling evangelist William Henry Wright came to Arlington. Like other early churches in Arlington, First Christian initially met in storefronts before building their first sanctuary in 1892 at the corner of Mesquite and South Streets. The church is shown here in 1897. In 1958, First Christian dedicated a new church on Collins Street.

This photograph shows the dedication of St. Williams Catholic Church, Arlington's first Catholic church, in June 1941. St. Williams was located on Division and Center Streets. In 1954, St. Williams was changed to St. Maria Goretti and moved to a new building on Davis Drive. With the move came the establishment of St. Maria Goretti Catholic School, which continues today.

Five

Destination Arlington
Where the Fun Begins

Arlington embraced the postwar boom with passion. Between 1950 and 1970, the population exploded from 7,692 to 88,385. The Dallas-Fort Worth Turnpike (I-30) opened in 1957, making travel to and from Arlington easier. General Motors rolled its first car off the Arlington assembly line in 1954 and employed hundreds of workers to produce Buicks, Pontiacs, and Oldsmobiles. Arlington State College changed from a junior college to a four-year institution in 1959. And in 1956, city leaders and developers envisioned a unique master-planned industrial park that would attract businesses to Arlington. The Great Southwest Industrial District soon became a model for industrial parks across the nation.

Great Southwest was built on the former site of Waggoner's Three D ranch and needed paved roads and sewer lines to be viable, but how to pay for them? Taxes? Business loans? No. In a moment of whimsy inspired by the newly opened Disneyland, planners decided that the money would come from burro rides and Wild West-style shoot-outs—thus Six Flags Over Texas was born. It opened in 1961 and was an immediate hit with visitors.

It is one of the great ironies of Arlington that as post–World War II city leaders worked earnestly to develop business and industry, Arlington instead became the region's playground. After the success of Six Flags, Mayor Tom Vandergriff pulled off an incredible coup by bringing major league baseball to Arlington in 1972. Suddenly, Arlington was the top tourist destination in the state.

Not everything was perfect. The marine-life park Seven Seas, which opened in 1972, had rough sailing and finally ran aground in 1975. Its short-lived successor, Hawaii Kai, hula danced through only one season in 1976. Overall, however, the Arlington entertainment machine kept growing. Wet 'n Wild water park opened across from Six Flags in 1982 and was replaced by Hurricane Harbor in 1997. The Ballpark in Arlington, built to replace Arlington Stadium, opened in 1994. The Dallas Cowboys opened their $1.15 billion, jaw-dropping new stadium in 2009. Through it all, Six Flags remained the icon of Arlington and the locus of the city's entertainment district.

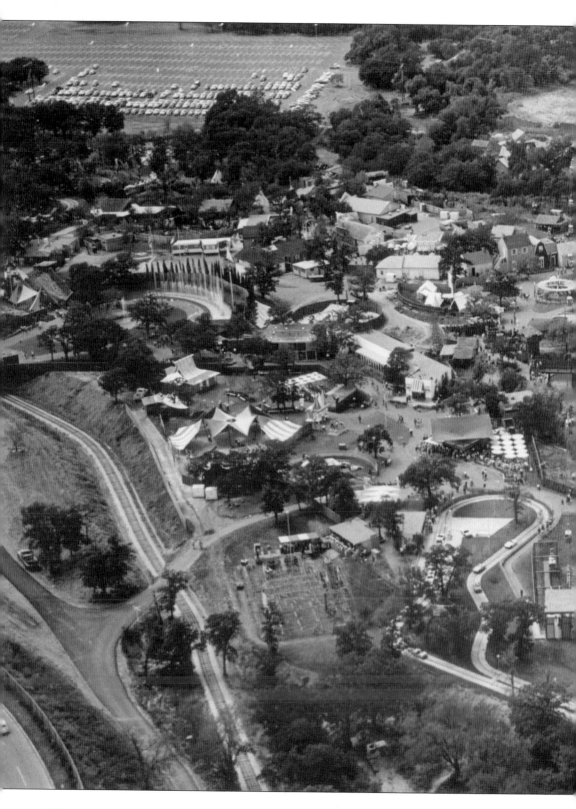

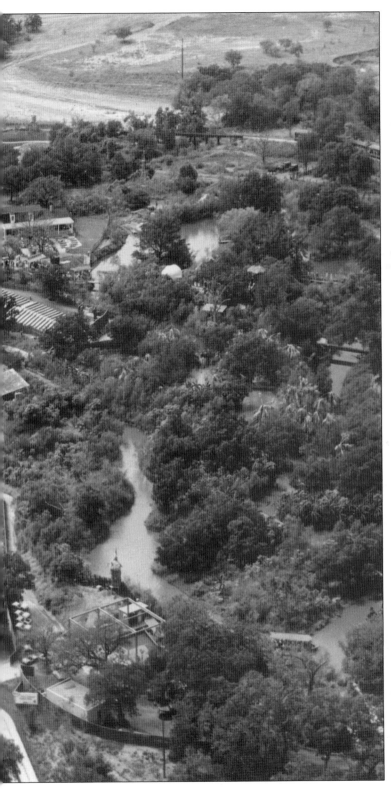

Six Flags opened August 5, 1961, to much excitement and fanfare. Kent Biffle of the *Fort Worth Press* said it was "an earthquake of thrills. A riot of color. A shellburst of excitement." Even posh Neiman-Marcus called Six Flags a "fabulous new Texas landmark." The $10 million park, shown here in August 1961, was the brainchild of Angus Wynne Jr., president of the Great Southwest Industrial District. He conceived of the amusement park as a way to provide improvement funds for the industrial park—a job it fulfilled beyond anyone's imaginings. The first name considered for Six Flags was Great Southwestland, but it was dropped in favor of the more representative Texas Under Six Flags. This name, too, failed to stick. In a 1994 *Fort Worth Star-Telegram* article by O. K. Carter, Wynne's son, Angus Wynne III, said, "Originally his name was Texas Under Six Flags, but some members of the Daughters of the Texas Revolution pointed out that Texas was never under anything. Dad agreed and changed it to Six Flags Over Texas."

Five-year-old Teresa Pool is first in line as she waits with her family for the opening of Six Flags on August 5, 1961. Admission was $2.75 for adults and $2.25 for children, which included access to all the rides and attractions. Waiting areas for the rides featured an amenity much appreciated during the hot Texas summers—outdoor air-conditioning.

As one of the park's first rides, the Butterfield Overland Stagecoach carried 15 passengers around a dirt track. Along the way, passengers ran into outlaw Sam Bass and his gang, confronted hostile Indians, and passed roaming buffalo. The ride closed after a calamitous 1967 accident in which 11 people were injured after a front wheel broke.

In its early years, Six Flags took great pains to pay homage to the state's heritage through its six themed areas: Spain, France, Mexico, the Republic of Texas, the Confederacy, and the United States. The bank shown in this photograph started life as an actual bank in the small town of Tom Bean, Texas. Angus Wynne Jr. bought the building and moved it to the Texas section of the park.

Wynne (center), shown with Martha (May) Martin (left) and an unidentified performer, was not afraid to get his hands dirty. A 1961 *Alcalde* article said, "At one point, [Wynne] . . . was picking up several cigarette butts when a guest stopped to observe: 'Surely a healthy-looking man like you could get a better job than this.' Angus Wynne Jr. looked up and smiled. 'Yes, ma'am, but I like it here.' " (Courtesy Martha Rose May Martin.)

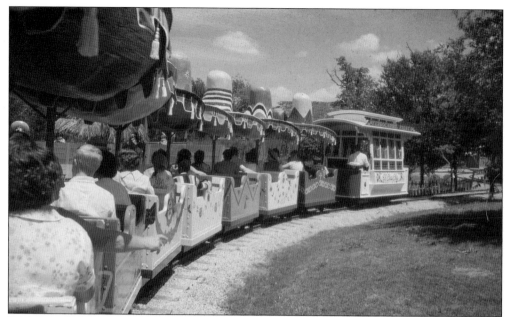

With its colorful cars and catchy tune ("Tra la la la la la, Fiesta!"), the Ferrocarril Fiesta Train was described by the *Dallas Morning News* as the "most hilarious train ride of all" in 1961. The train took passengers through a caricature of Old Mexico, complete with giant dancing tamales. Brothers Sid and Marty Krofft redesigned the ride in 1968, replacing the sombrero-topped cars with a dragon theme.

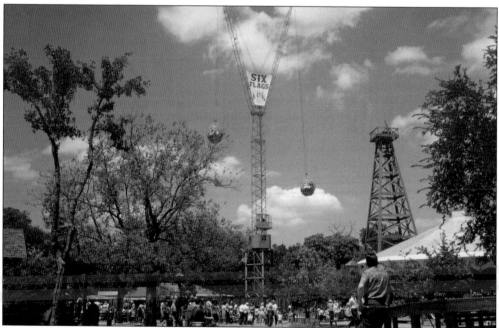

The 155-foot-high Sky Hook (center) gave passengers a bird's-eye view of the park and surrounding city. Twenty-eight people would sit inside the circular cage, then rise into the air as the other side descended. The top of the Y-shaped structure rotated. The Sky Hook debuted at 1958 Brussels Expo and then moved to Texas for the 1963 season. In 1969, it moved to Six Flags over Georgia.

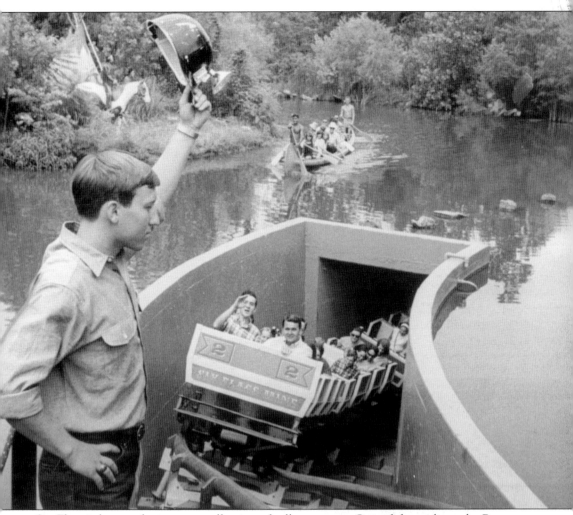

Six Flags is known for its great collection of roller coasters. One of the earliest, the Runaway Mine Train, opened in July 1966 as the first tubular steel, themed roller coaster and influenced coaster design across the country. Six Flags employee Steve Schellenberg (left) waves to guests as they emerge from the underwater tunnel on the ride's opening day. The tunnel was prone to flooding, particularly after big rains, and the ride required large sump pumps to keep it operational. According to park officials in 1966, the Runaway Mine Train and the log flume ride (formally called El Aserradero) were the park's most popular attractions. Both rides are still in operation at the park.

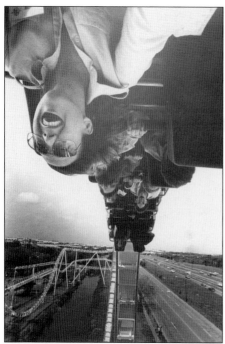

At nearly 12 stories high, Six Flag's Shock Wave, shown here at its debut in 1978, was the world's tallest roller coaster. It was also the second double loop coaster in the world, the first being in Cleveland. With speeds of 60 miles per hour, Shock Wave remains a favorite among coaster enthusiasts.

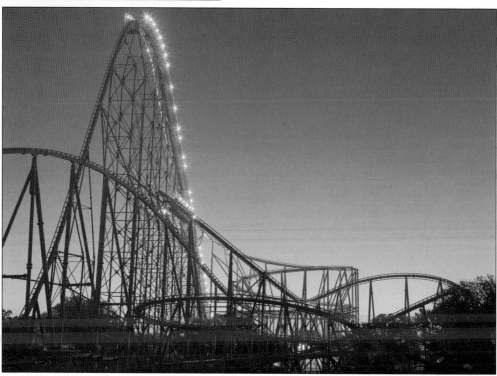

Built in 2001, the Titan lives up to its name. Twenty-five-and-a-half stories tall and reaching speeds of 85 miles per hour, the coaster's mile of steel track careens through tunnels, spirals, and drops. Coaster enthusiasts from around the world consistently rate it as one of their favorites. (Courtesy Six Flags Over Texas.)

114

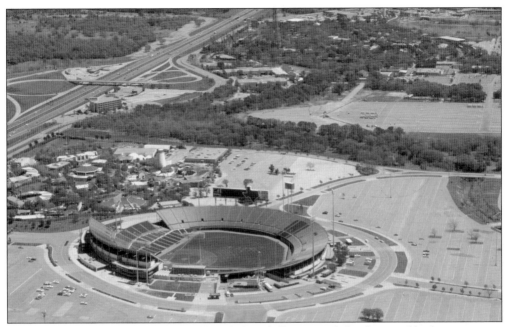

For 13 years, Mayor Tom Vandergriff single-handedly pursued the dream of bringing a major league baseball team to the city. The first step was to build a facility that would attract a team. Built for $1.9 million, Turnpike Stadium opened in 1965 with a seating capacity of 10,500. For seven years the stadium served as home for the minor league Dallas-Fort Worth Spurs, which played in the Texas League.

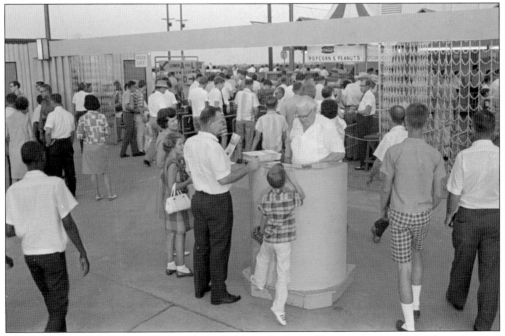

Fans buy programs at Turnpike Stadium for the July 14, 1965, game between the Texas League All Stars and the National League Houston Astros. The Astros were the first major league team to play in Turnpike. They beat the All Stars 5-1 before a crowd of 11,000.

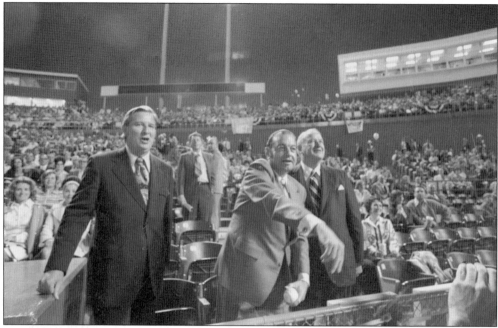

In 1971, Vandergriff finally succeeded in luring the Washington Senators to Arlington. The Senators became the Texas Rangers, and Turnpike was renamed Arlington Stadium. Many wanted to name the stadium in Vandergriff's honor, but he declined. Here, Vandergriff throws out the first pitch at the Texas Rangers' opening home game on April 21, 1972.

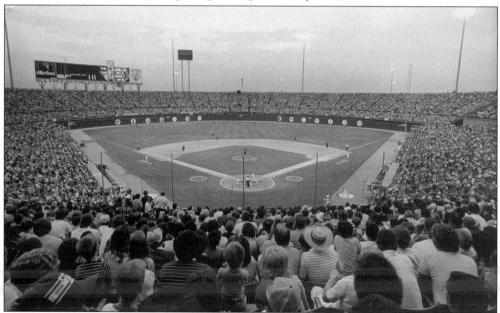

Arlington Stadium, shown here in 1977, had several notable features. It was naturally situated in a geographic bowl, making the playing field 40 feet lower than the parking lots. Also, the Texas-shaped scoreboard attracted much attention until it was removed in 1983. But mostly Arlington Stadium was known and feared for its oppressive heat. Because of the complete lack of shade, the Rangers always played summer games at night.

Nolan Ryan held a press conference on December 15, 1988, after leaving the Houston Astros to join the Texas Rangers. While Rangers fans were overjoyed at Ryan's coming, Houston fans expressed anger with Astros owner John McMullen for not trying to keep Ryan on the team. A Houston-area mall Santa went on record as saying, "The Astros aren't going to get anything this Christmas, except maybe a few ashes."

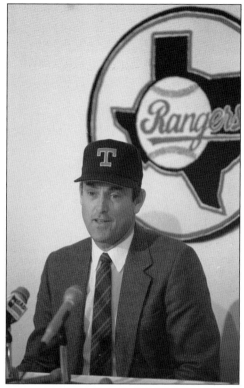

At age 42, Nolan Ryan pitched strike number three of his 5,000th strikeout on August 22, 1989, in Arlington Stadium. His victim was Rickey Henderson of the Oakland Athletics. Ryan retired from the Rangers in 1993 with 5,714 career strikeouts and seven career no-hitters. In 2008, Ryan was hired as the Rangers' team president. In 2010, he became part owner of the team, and the Rangers made their first-ever appearance in the World Series.

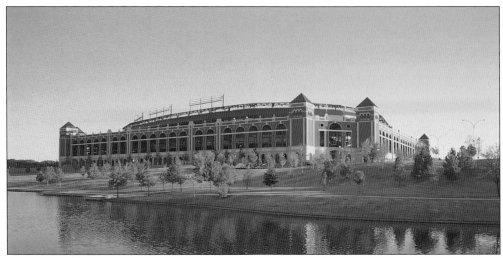

Arlington Stadium was demolished in 1994 in favor of the new $191 million Ballpark in Arlington, built a quarter-mile southeast on one of the stadium's old parking lots. The Rangers played their first regular season game there on April 11, 1994, against the Milwaukee Brewers. Fort Worth pianist Van Cliburn played the national anthem, accompanied by the Fort Worth Symphony Orchestra. Despite the rave reviews over the Ballpark's architecture and facilities, opening day had its troubles. First was an hour's rain delay, then the Rangers lost 3-4. Finally, and more seriously, a fan fell 30 feet from the upper deck after the game ended, suffering multiple injuries, including a broken neck. (She eventually recovered.) The Ballpark changed its name to Ameriquest Field in 2004, and then to Rangers Ballpark in Arlington in 2007. (Both, courtesy City of Arlington.)

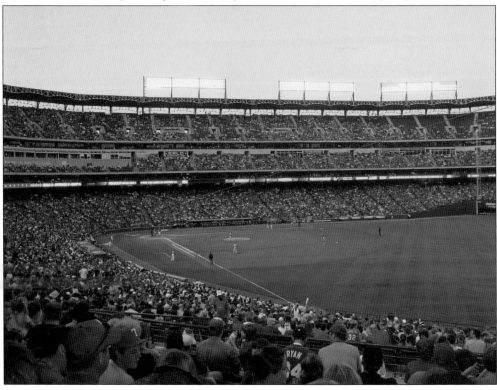

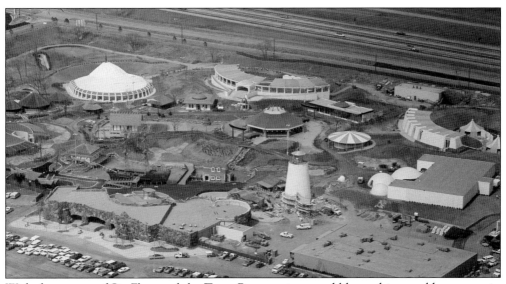

With the success of Six Flags and the Texas Rangers, it seemed like nothing could go wrong in Arlington. Seven Seas, a $13.4 million sea life park, put an end to that idea. The city built Seven Seas in a prime location—right between Arlington Stadium and Six Flags—and opened it on March 18, 1972. Admission was $2.75 for children and $3.75 for adults. True to the Seven Seas theme, the park was divided into seven areas: Arctic, Mediterranean, Indian, Sea of Cortez, Caribbean, Sea of Japan, and South Seas. Some notable attractions included Newtka the Killer Whale, roller skating penguins, an underwater puppet show, and the park's lone ride, an Arctic adventure that brought passengers face-to-face with the Abominable Snowman.

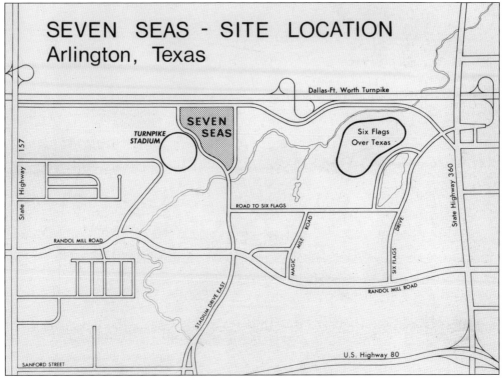

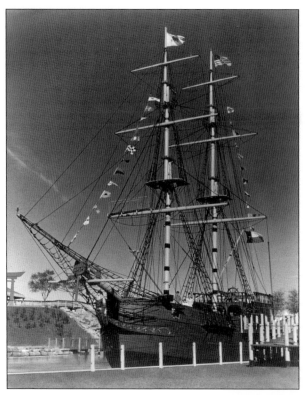

The *Bona Venture*, an 18th century–style pirate ship, sat docked in the Caribbean section. According to a 1980 article by Al Harting in *D Magazine*, the ship had pneumatic cannons that "fired hard rubber balls across a pool—and more often than not into pedestrian traffic." Guests were not allowed on deck, but a crew of swashbuckling "pirates," trained in martial arts by Biff Painter, thrilled audiences with their swordplay along the rigging. There was even a high-dive act from the 100-foot mast. Below deck, children could play video games. Even after the park closed in 1976, the ship remained standing and was later incorporated into the Arlington Sheraton Hotel's swimming area in 1985. The Bona Venture burned October 15, 1992, as the result of an electrical short.

The creature shown at right is Orchin, a cross between an orphan and an urchin (presumably the child kind of urchin, not the sea urchin). Stephen Campbell (left) seems as confused by it as others must have been. This photograph was taken March 18, 1972, during opening day ceremonies for the park.

One of the stars of Seven Seas was Pancho, a pipe-smoking, ill-tempered sea elephant. Here, Pancho shakes hands with Mayor Vandergriff. According to an article by *Fort Worth Star-Telegram* columnist O. K. Carter, Pancho came in second to Vandergriff in a 1973 mayoral election after garnering five write-in votes. As quoted by Carter, Vandergriff said, "I don't know what I've done that five people wouldn't vote for me."

While Seven Seas had plenty of shows like these synchronized swimmers, it lacked rides because of a non-competion agreement with Six Flags. Although the shows' scripts would change each year, the animals' behavior was basically the same for each visit. As Seven Seas manager Hollis Pollard said in a 1976 *Dallas Morning News* article, "Word got around that once you've seen it, you've seen it."

Seven Seas employees Sylvia Coleman (left) and Leo Scott watch Newtka the Killer Whale. In this photograph, taken October 1974, the employees wear black armbands to protest the city's decision to close the park permanently. In fact, the park opened for one last year in 1975 under different management before closing.

Billing itself as a completely new and different park, Hawaii Kai opened in 1976 on the old Seven Seas grounds and applied an island theme to the old Seven Seas buildings. Hawaii Kai took the Hawaiian theme seriously and flew in Hawaiian teenagers to work at the park. Here, Mayor Tom Vandergriff accepts a ceremonial pig from King Kekoa (Lester P. Cabral) of Honolulu. Attractions included a dolphin show, deer, and hula dancers. Although city leaders put on a brave face and touted their optimism over the park's opening, the truth was that Hawaii Kai, like Seven Seas before it, was in severe financial difficulties, and attendance at the park was sluggish. The park lasted one season and then closed permanently.

The $18.5 million Wet 'n Wild park, shown here in 1986, opened May 1982 and finally gave Arlington a viable water park. In 1992, a year-round companion park, FunSphere, opened next door with miniature golf and go karts, but closed in 1995. Six Flags Theme Parks purchased Wet 'n Wild in 1995 and changed the name to Hurricane Harbor in 1997.

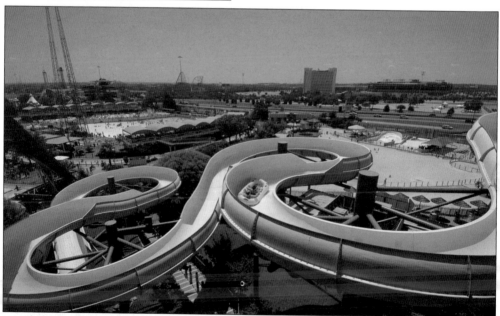

Hurricane Harbor opened May 10, 1997, with a brand new raft ride called the Sea Wolf, shown here. To reflect the change from Wet 'n Wild, Hurricane Harbor cultivated a Caribbean theme. One-day prices were $18.32 for children and $22.96 for adults. On the opening day of Hurricane Harbor's first regular season, Olympic gold medalist Ryan Berube of Dallas visited to try the rides. (Courtesy Six Flags Hurricane Harbor.)

Arlington has become defined by baseball and amusement parks, but it is by no means limited by those entities for entertainment options. River Legacy Parks attracts hikers, bikers, and birdwatchers from across the Metroplex. Shown here is 1991's "Pretty Fishy—the Sequel" from the annual Cardboard Boat Regatta held at River Legacy Parks. The regatta was moved to Hurricane Harbor in 1997.

River Legacy started in 1976 with the donation of 204 acres by pioneer descendents Margaret Rose May and her sister and brother-in-law Berta Rose and J. O. Brown. Today the park comprises 1,300 acres and offers educational opportunities for students at its Science Center. These children are measuring a boa constrictor under the supervision of Jim Fowler from Wildlife Kingdom. (Courtesy River Legacy Foundation.)

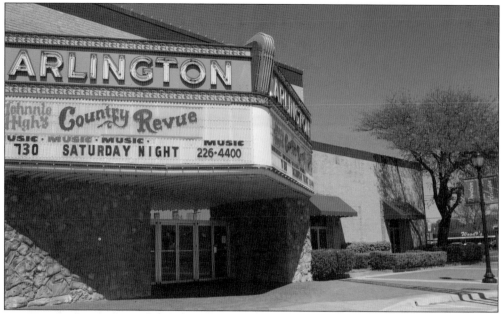

Since 1994, Johnnie High has staged his weekly country music shows in the refurbished Arlington Movie Theater. High got his start singing and playing guitar on his own weekly radio show at the age of 14. Later in life he encouraged and developed emerging talents like LeAnn Rimes, Lee Ann Womack, and Steve Holy. High died in 2010, but his show continues. (Courtesy Arlington Music Hall.)

The Levitt Pavilion for the Performing Arts, one of several Levitt Pavilions across the country, opened in Arlington in October 2008. Over 1,800 people attended the premiere concert by Brave Combo. The pavilion sits in Founders Plaza Park, which includes historical markers about the Collins, Cooper, Ditto, Rankin, Rogers, and Rose families, as well as a bust of Andrew Hayter. (Courtesy Evelyn Barker.)

Visible from miles away, the $1.15 billion Cowboys Stadium opened May 2009 to fireworks and fanfare. "This is the biggest freakin' thing I have ever seen," wrote a sports reporter for the *Lubbock Avalanche-Journal*. Echoing the Cowboys' former home of Texas Stadium in Irving, the new stadium features a retractable roof so that "God can watch his favorite team play." (Courtesy Dopefish.)

Arlington became "the mecca of bowling" when the International Bowling Museum and Hall of Fame moved here from St. Louis in 2010. The museum offers a look at the 5,000-year history of bowling, while the attached training and testing center is home base for bowling's Team USA and Junior Team USA. (Courtesy Evelyn Barker.)

Search for your hometown history, your old stomping grounds, and even your favorite sports team.

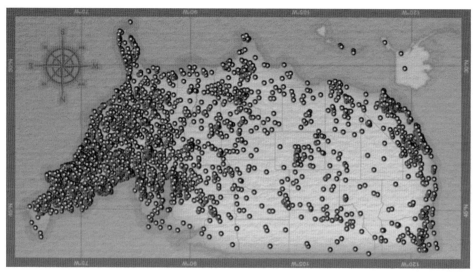

Find more books like this at
www.arcadiapublishing.com

Arcadia Publishing, the leading local history publisher in the United States, is committed to making history accessible and meaningful through publishing books that celebrate and preserve the heritage of America's people and places.

DISCOVER THOUSANDS OF LOCAL HISTORY BOOKS FEATURING MILLIONS OF VINTAGE IMAGES